IMAGES
of America

DEARBORN

MICHIGAN

DATE DUE

Cover: Henry Ford uses a watch to fascinate some children.

IMAGES
of America

DEARBORN
MICHIGAN

Craig Hutchison and Kimberly Rising
Dearborn Historical Museum, City of Dearborn

ARCADIA
PUBLISHING

Published by Arcadia Publishing
Charleston SC, Chicago IL, Portsmouth NH, San Francisco CA

Printed in the United States of America

Library of Congress Catalog Card Number: 2002115513

For all general information contact Arcadia Publishing at:
Telephone 843-853-2070
Fax 843-853-0044
E-mail sales@arcadiapublishing.com
For customer service and orders:
Toll-Free 1-888-313-2665

Visit us on the Internet at www.arcadiapublishing.com

*This book is dedicated to "Gran," who loved Dearborn, always believed,
never wavered, and imparted her faith to those around her,
which is the greatest thing any human being can do.
Thanks for being the example you were and still are today.*

CONTENTS

ACKNOWLEDGMENTS

The development of a book such as this can be an exhilarating experience and at the same time can bring frustration until the manuscript is handed off. In helping us to get over the mountains and through the valleys, we would like to thank a number of people. We look back with appreciation for the help of the Dearborn Historical Museum's staff in tracking down, from an exceptional collection, the images that we needed. A special thanks to Mary MacDonald, Chief Curator at the Museum, whose kindness and helpfulness will not be forgotten. The world of history could use more people like her. We would also like to thank Dr. Martin Hershock for his input, which we found highly valuable; it is a pleasure to talk to someone who loves history as much as Marty. When the manuscript was still in its infant stage, Alison Kline helped us get a clear, overall picture of our goal. A hearty thank you goes out to Jerry Davis, who sat on the phone for hours as we bounced our text off of him; his input was invaluable. Thanks to Mom and Dad for their support, which means more than they will ever know. They have been a rock to us. More than anyone, though, we want to thank our Heavenly Father, who lent us a few talents to allow us to do something like this: write a book that will hopefully make a difference and mean much to many.

Craig E. Hutchison, Managing Editor
Kimberly A. Rising, Graphic Designer
Wandering Wolverine Publishing Company
www.wanderingwolverine.com

INTRODUCTION

The area that people know today as the City of Dearborn has been through many changes and interesting events throughout its history. From a historical perspective, there have been many eras, many transitions, many significant people, and many seminal events that have transformed Dearborn into the multifaceted, modern place it is today. Stated simply, Dearborn has a rich history and there is much to tell.

From the Native Americans to the early French settlers who set up ribbon farms along the Rouge River, the early years of the area speak of a time when the land was not changed much by the peoples who roamed the area for hundreds of years. The influx of early pioneers who came to purchase land they could call their own and cut a life out of the forest is another story of Dearborn. The opening of the Erie Canal, which made it easier for westbound settlers to get to the Michigan country, the dreams they all had as they headed to a new land, is all but forgotten in the modern day of an "organized life."

The lives of those early pioneers centered around survival: shelter, food, water, clothing, and finding or making those necessities involved a kind of "living" completely foreign to most people today. Imagine arriving at a tract of land that is supposed to be transformed into a farm and all you can see for miles around are trees. It cannot be overstated that "the forest meant very hard work for the settler: so much that nowadays one is apt to wonder how on earth any of them accomplished it." The railroad's arrival at Dearbornville opened opportunities for work, travel, and more settlement. That Dearborn was ever the grounds for a United States Arsenal seems almost unbelievable to today's citizen, if not for the Commandant's Quarters standing there to remind everyone. The changes the arsenal brought were important to an area that needed a focal point. This complex would have the need for numerous services and skills, brick-making being one of the most important. In that day, the Dearborn area seemed so far from Detroit and, indeed, in terms of the transportation of the time, it was remote. Complaints about the roads being bad are commonly heard today, but imagine a time when men built log cabins and waited for the roads to get better because there was no way to traverse the few trails that were there. These are more stories of Dearborn.

A big change was coming, however, and its name was industrialization. Henry Ford, in the early 1920s, brought mass production to the small villages of Dearborn and Springwells, which each had less than 5,000 residents as the time. He brought with him the moving assembly line, and it wasn't long before both villages combined numbered 50,000 people. The area would never be the same again. People flocked there from all over the world for a chance to work at the Ford Rouge Plant. Different ethnic groups worked side by side for a better life. The eras and

events continue to flow throughout the history of the Dearborn area: the Great Depression, the World Wars, Mayor Hubbard's tenure, religious worship, education—the list is virtually endless because Dearborn has experienced so much. Its transformation into the modern city that it is today is nothing short of remarkable.

In this book, we hope to tell some of these stories. Our intent is to present some of the turning points and a few of the factors that affected the city that is so well-loved today. We ask that you bear in mind that, due to space considerations, we could not cover everything that has ever happened in Dearborn. No doubt, you will notice subjects that are not covered. There is no way around this reality; some topics just could not be covered, even as much as we would have liked to have written about everything. What we do hope is that the thematic approach we took will be meaningful to you and that when you read through the book, you will find it informative, insightful, and interesting.

There is something that exists in human beings that yearns to make a connection with the past: "He is lifted beyond and above himself into higher worlds where he talks with all his great ancestors, one of an illustrious group whose blood is in his veins and whose domain and reputation he proudly bears." If you, the reader, can say this about your experience with this book, it will have served the purpose with which we started out. Enjoy the images, the text, and the people, places, and stories of Dearborn contained herein.

One

THE AREA THAT WOULD BECOME DEARBORN

The seal of the City of Dearborn notes a significant date: "Settled 1786." What was Dearborn like in 1786? A good description, in one word, would be wilderness; the area was relatively flat and covered with a dense forest. The French had laid claim to the territory in 1603, then the British took control in 1760, and finally, with the end of the American Revolution, the Americans annexed all of the land around the Great Lakes in 1783, though the United States did not officially take control of the area until 1796.

In 1786, Pierre Dumais and his family cut a farm out of the forest along the banks of what the French had dubbed the Rouge River ("red river") in what is now known as the southeastern part of Dearborn. A few years later, in 1795, James Cissne was the first settler in what is West Dearborn today. These early settlers were of French ancestry and were the first people to set down permanent roots in the area.

For hundreds of years prior to the arrival of the French, Native Americans traveled by canoe up the Rouge River and used the area to hunt and fish. The woodland tribes, which included the Ottawa, Potawatomi, Saux-Fox, and Chippewa, never used the area as a permanent settlement, but regularly camped along the banks of the Rouge, which was clean, clear, and teeming with fish such as pike, bass, and trout.

The area was 10 miles from the Detroit River and was a densely forested land. One of the main travel ways, the Rouge River provided a path to the interior of the land. By land, there was an Indian trail known as the Great Sauk Trail. It was the most important Indian trail in the Great Lakes region and was used by French explorers, fur traders, and missionaries. Some of the early French settlers (1780–96) established "ribbon farms," narrow pieces of land that fronted the river while the rest of the farm extended into the forest. This gave a farmer access to the markets in Detroit via the waterway.

French settlement ceased with the American military occupation of the area in 1796. The Michigan territory was officially created in 1805 by Congress, and the lure of inexpensive, quality land brought a slow influx of settlers from the east. The reason for the slow pace of settlement at first was that the area was difficult to reach, and even if one did make it and set up a farm, it was equally difficult to make a profit on produce due to the cost of transporting goods by wagon over hundreds of miles. Settlement increased tremendously with the building of the Erie Canal, which was completed in 1825. Westbound pioneers could now ride up the Hudson River, through the Erie Canal to Buffalo, across Lake Erie by steamboat, and up the Detroit River. The canal reduced a once 5-to-10 day arduous land journey to a 44-hour water route.

One of the best ways to gain insight into the area and to learn what life was like during its early settlement is to study William Nowlin's *The Bark Covered House*. The book is a chronicle of his family, who journeyed to Dearbornville via the Erie Canal in 1834. Many of the details related in the text describe a life completely foreign to the 21st-century individual. Much of the forest was populated by hardwoods such as maple, oak, hickory, and beech. These trees had to be cut and cleared for farmland and the logs fashioned in order to build a cabin by hand. According to Nowlin's text, this was no small matter, "no man, unless he has experienced it himself, can have an adequate idea of the danger and labor of clearing a farm in heavy, timbered land. Then he knows something of the anxieties and hardships of a life in the woods." Mosquitoes could make life miserable, at times, as the pioneer relates: "the woods were literally alive with them. No one can tell the wearisome sleepless hours they caused us at night. We had them many years, until the country was cleared and the land ditched; then, with the forest, they nearly disappeared." Food usually came by a man's own hand: meat by hunting and vegetables by farming. Raising a farm and living on the frontier was labor-intensive and could make for a hard life, according to Nowlin: "We ofttimes encountered perils and were weary from labor, oftentimes hungry and thirsty, often suffered from cold and heat, frequently destitute of comfortable apparel and condemned to toil as the universal doom of humanity—thus earning our bread by the sweat of our brows."

Like many of the early pioneers, however, the Nowlins were not to be deterred from cutting out a life on the frontier in this beautiful new country. It was first-rate farming country and for that, the early settlers were very thankful. Different kinds of creatures were plenteous in the days of the early settlers including wolves, bears, deer, fox, and snakes.

Not long after the Nowlins arrived in the area, while the Rouge River and the Chicago Road (formerly the Great Sauk Trail, dubbed a military road in early 1800s and renamed) were still very important transportation routes, another mode of transportation appeared on the scene. In 1837, the year Michigan became a full-fledged state in the Union, the first railroad cars and steam locomotives were seen in the area. This meant not only more mobility and settlers, but also that the trees in the area would be valuable to early settlers like the Nowlins, as the wood could be sold for both a power source and as railroad ties. Previous to the arrival of the railroad, the main tree-derived product that settlers could actually sell was ash, used in the making of soap.

According to William Nowlin, the first locomotives made quite an impression: "we thought, surely, a new era had dawned upon us, and that Michigan was getting to be quite a country." The account Mr. Nowlin laid down, he thought, would be of great interest to future generations for, as he wrote, one "can never too fully appreciate the blessings earned for them by their parents and others amid hardships, privations, and sufferings (in a new country) the half of which can never be told." Today, that country is known by the name of Dearborn.

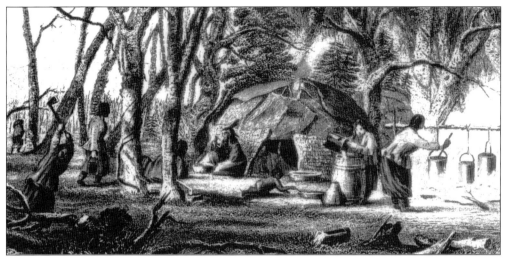

The Woodland Indians in southeastern Michigan lived a nomadic life, with the Rouge River as one of their main modes of transportation. They would come and go, setting up camp for a time as they fished and hunted for food and skins: bear skin for blankets and deerskin as clothing. Their homes, as drawn here, were called hogans. (Photograph courtesy Dearborn Historical Museum.)

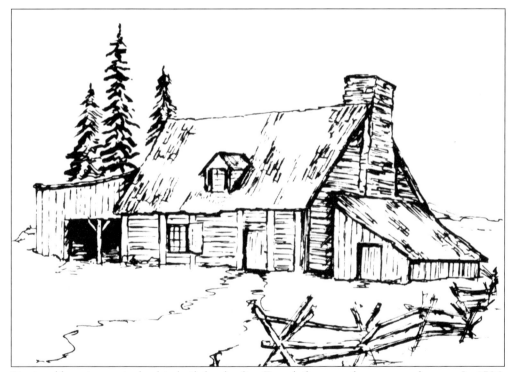

Depicted here is a typical cabin built by the first French farmers who came to the area. In 1786, Pierre Dumais, a French-Canadian fur trader, cleared the virgin woods and with his family, built a cabin and farmed a tract of land along what is today Morningside Street in Southeast Dearborn. (Photograph courtesy Dearborn Historical Museum.)

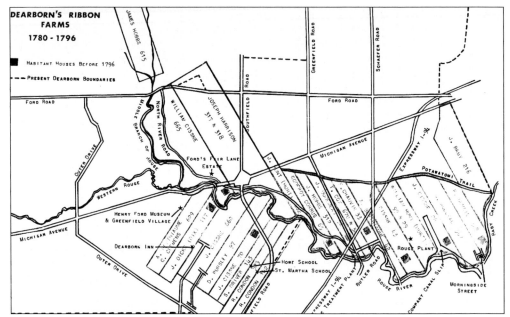

The ribbon farms created by these early settlers were so-called because only a small portion of the land fronted the river, while the rest of the farm extended into the forest, sometimes miles deep. This map shows the location of these early farms in reference to the present-day boundaries of Dearborn. Much of the land was given as a gift from the Potawatomi tribe to Frenchmen who were coming into the area at this time. (Photograph courtesy Dearborn Historical Museum.)

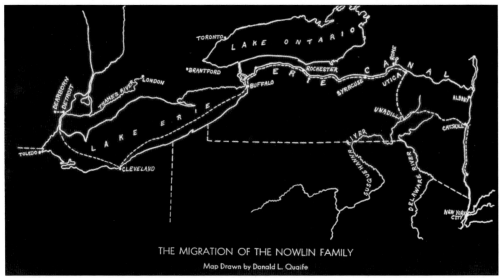

When the Erie Canal opened in 1825, the influx into the Michigan Territory increased tremendously. The Nowlin family were early pioneer settlers in the Dearborn area who would have traveled the route of this map. After traversing the canal to reach Buffalo, the steamer they boarded was fittingly dubbed the *Michigan*. Once they reached Detroit, they headed up the Rouge River to the interior. In addition to shortening the journey west, the canal also helped the farmer on the frontier because it allowed him much easier access to the markets back east. (Photograph courtesy Dearborn Historical Museum.)

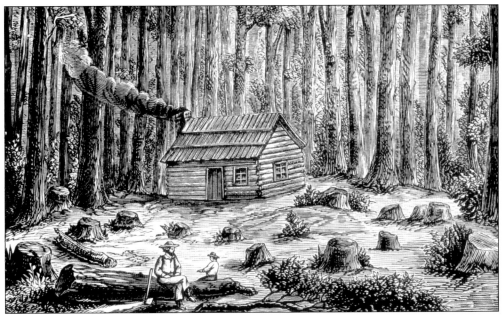

Pictured is the first cabin built by the Nowlins when they reached the Dearborn area in 1834. The house is today called "The Bark Covered House" based on the first hand account set down by William Nowlin years after he had lived the experience as a boy. A quote from his account shows the necessity and pioneer spirit of the day: "Father immediately commenced cutting logs for a house . . . cut black ash trees, peeled off the bark to roof his house . . . we moved into a house of our own, had a farm of our own and owed no one." (Photograph courtesy Dearborn Historical Museum.)

The railroad reached Dearbornville from Detroit in 1834. This was a boon to area settlers: there were job opportunities laying track and they would now have a market for their wood, to be used first as railroad ties and then as firewood for the locomotive engine. (Photograph courtesy Dearborn Historical Museum.)

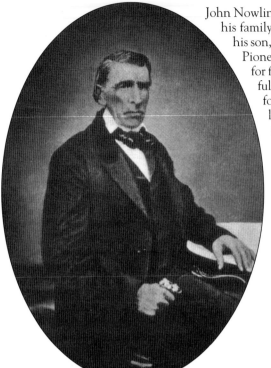

John Nowlin was one of the early pioneers who brought his family from the east up the Rouge River to what his son, William, described as "a beautiful country." Pioneers like the Nowlins helped pave the way for future generations. They were hard workers, full of courage, and determined to forge a life for themselves on the frontier. Even in the lifetime of his son, it was evident what the early pioneers had accomplished in clearing and establishing the land for future settlers. His son put it this way in his account: "the country shows what they have done." (Photograph courtesy Dearborn Historical Museum.)

Melinda Nowlin, wife of John Nowlin, helped with the sometimes overlooked necessities that were vital to living in this new country: cooking, cleaning, spinning, weaving, knitting, mending, washing, nursing, and teaching the children. (Photograph courtesy Dearborn Historical Museum.)

Two

THE DETROIT ARSENAL
IN DEARBORNVILLE

A very important event in the development of the Dearbornville area was its selection as the site of a United States Arsenal. An arsenal had existed in Detroit, however, by the 1830s, the population of the city had grown to the point where many people feared that the explosive materials the arsenal housed posed a danger. Congress decided to build a new arsenal on a 232-acre plot of land in the small village of Dearbornville.

Construction started in 1833 and by the time most of it was completed in 1837, the villagers had become more than just farmers. Opportunities had arisen to engage in a number of different trades: brickmaker, tradesman, blacksmith, and even saloon-keeper. Many settlers moved to town, which created a more centralized village. The 1839 *Gazetteer of the State of Michigan* not only describes the change that the arsenal had helped bring, but also provides some insight into how the complex was organized:

> *Dearbornville is a flourishing village. Here is located the United States Arsenal. This was commenced in 1833, and completed in 1837. It consists of eleven buildings, built of brick, arranged around a square, whose side is 360 feet. The principle building occupies the center of the eastern side of the square, and is 120 feet long by 30 deep, and three stories high, exclusive of the basement. This is intended for the depot of arms. The buildings surrounding this square, are connected by a continuous wall of heavy masonry, 12 feet high, all calculated as a defense against an invading or insurrectionary foe. The buildings are calculated to accommodate two officers, and 50 artificers and workmen, and, in case of emergency, they can easily accommodate double that number. The whole object of this institution is not a military station of soldiers, but for the mounting and equipping of artillery; repairing small arms, and the preparation of all the other numerous munitions of war. It is intended more particularly for the supply of Michigan and Wisconsin, in time of war, and to issue to both, in time of peace, such arms and equipment as each State, by the Acts of Congress, are thereunto entitled.*

The arsenal's main function was to store, develop, manufacture, test, repair, and provide arms and ammunition to what was known at the time as the Western Frontier. Its function changed during the Civil War when the arsenal was utilized as a training center for recruits who were then sent south to fight the Confederate armies. By the time the arsenal closed in 1875, shortly after the Civil War, the complex had not only ushered in a new era for the area, but helped change the community from a farming center to a mixture of farming, industry, and services. Throughout the arsenal's history, each structure in the complex served a unique purpose.

The Armory, largest of the arsenal buildings, was a storehouse for ordinance equipment and quartermaster supplies, and was a social center for military and community events. Around 1877, this building became a civic center called "Liberty Hall." Activities such as dancing, roller skating, dramatic plays, lodge meetings, and other functions made this former military installation valuable. In 1899, the Armory was converted into the Arna Woolen Mills; a fire in 1910 destroyed the 120-foot structure. Later, new homes were made from the salvaged bricks. Some still stand in the vicinity. In 1964, the Dearborn Historical Museum excavated a portion of the foundation and unearthed artifacts.

The Sutler's Shop was an early post exchange where personal items, such as toiletries, were sold to the Arsenal soldiers. The structure still stands today, but has been altered and is used as a doctors' clinic. Little is known about the Guard House, the enlisted men's Barracks, and the Surgeon's Quarters. During the years following the closing of the arsenal, they were used as residences. All three were razed in 1892 for the Dearborn Public School. In the 1880s, a two-story building was erected between the Carpenter's and Blacksmith's Shops. It was occupied by a lumber mill, a canning company, the Detroit-Dearborn auto factory, a machine shop, and a paint shop.

The Saddler's Shop, originally used for making and repairing equipment for horses, was purchased in 1877 by Dearborn Township and was converted into a town hall. Township meetings were held there until 1928 when the property was sold to S.S. Kresge and the building removed. The Gun Carriage Shed had a second story added in 1906 and was used as the first headquarters of the Masonic Temple. At the present time, various businesses occupy the building. The Arsenal Office was used first as a residence and later as a Boot and Shoe Repair Shop until it was demolished in the early 1900s.

The Commandant's Quarters served as home to 19 commandants who lived there until the arsenal closed in 1875. Following the closing, the structure was used for a number of different purposes: a multiple dwelling, jail, courthouse, first local library, township and city offices, school, church activities, and police station. In 1950, the building was dedicated as the City of Dearborn's first historical museum. The brick structure is situated along the old Chicago Road (now Michigan Avenue, U.S. 12) and holds the distinction of being the oldest building in the city still standing on its original site. Within its walls is preserved a bygone era when Dearbornville was a small rural community. The State of Michigan considers the building to be one of the seven most significant buildings in Michigan. The Powder Magazine, built in 1939, was located over 900 feet east of the arsenal. It was converted into a private farm residence in 1883 by the Nathaniel Ross family. When the last family member, Mary Elizabeth "Lizzie" Ross, died in 1950, she had specified in her will that the home, land, and outbuildings be given to the City of Dearborn for use as a museum.

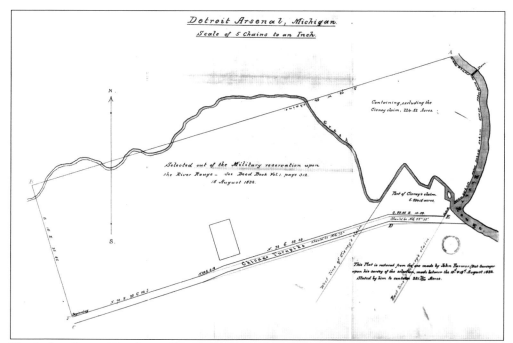

The little village of Dearbornville was chosen as the site for a new U.S. Arsenal for two reasons. Detroiters worried about having explosive materials so close to a populated area, and the government had learned a lesson during the War of 1812 when Detroit was captured along with the arsenal that existed there. Situating it in an outlying area would solve both of these problems. Construction was completed in 1837. (Photograph courtesy Dearborn Historical Museum.)

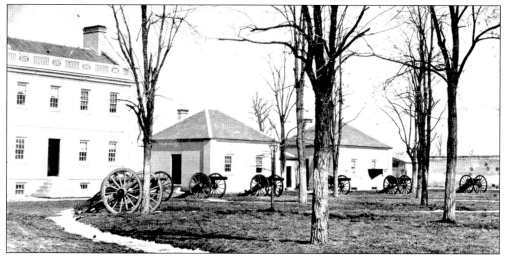

This picture, taken in 1868, shows three of the old arsenal buildings. The building on the left was used as a barracks, and the structure in the middle was the Guard House, sometimes used as a residence. These two were razed for a school at the northwest corner of Garrison and Monroe Boulevard. The building on the far right was the Sutler's Shop, a post exchange where personal items such as toiletries were sold to arsenal soldiers. This building has been altered and is now a doctors' clinic on the northeast corner of Garrison and Monroe Boulevard. (Photograph courtesy Dearborn Historical Museum.)

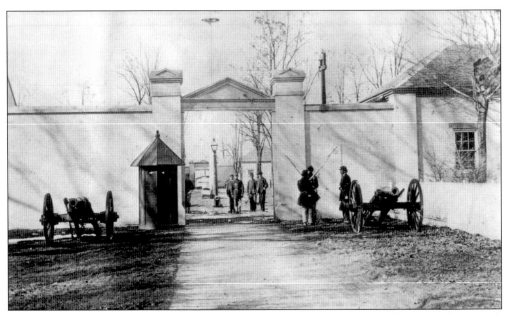

This was the South or Main Entrance of the U.S. Arsenal in Dearbornville. This photograph was taken during Civil War, c. 1864. The picture shows the changing of the guards. The canon was used for salutes. Salutes were fired by a single gun at sunrise and sunset and during the raising and lowering of the flag. When a salute was fired, the canon was brought forward and pointed towards the west. (Photograph courtesy Dearborn Historical Museum.)

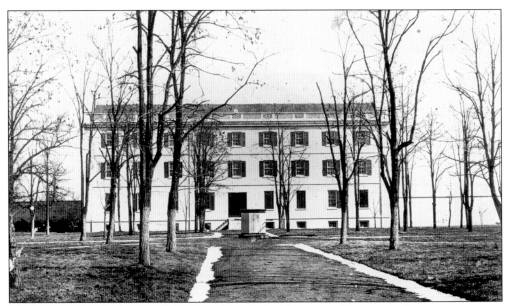

The Armory was the largest of the arsenal structures. It was used to store ordinance equipment and quartermaster supplies. The building also served as a social center for military and community events. In 1877, after the arsenal had closed, it became a civic center and then in 1899, the building was converted into the Arna Woolen Mills, where imitation buffalo robes and blankets were made. In 1910, a fire destroyed the structure. (Photograph courtesy Dearborn Historical Museum.)

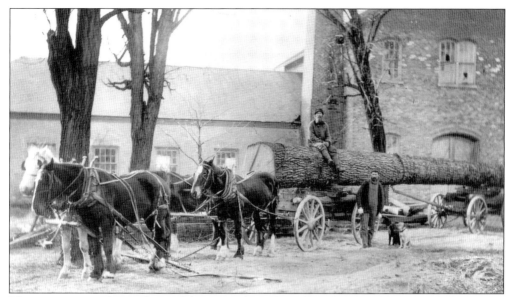

This picture was taken in front of the Arsenal Smith and Carpenter's Shops in 1883. A team of horses pull two wagons holding a 2000-pound black ash log. Mr. Abraham Moody and his son Thomas are shown in the picture. The two-story building to the right is a lumber mill erected in the 1880s and not a part of the original arsenal structures. The Detroit Dearborn Motor Car Company occupied the buildings in the early 1900s. After it was abandoned and sold by the government, it served several purposes, including use as a woodshop, and finally, as a modern garage. (Photograph courtesy Dearborn Historical Museum.)

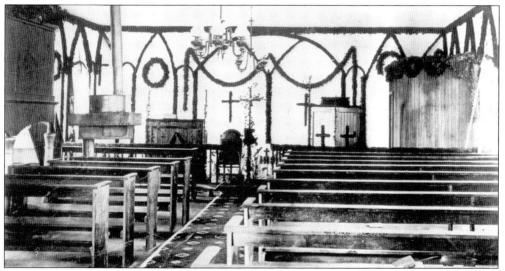

Around 1865, after the Carpenter's Shop had become unnecessary, it was turned into the Arsenal Chapel. The work of converting it into a chapel was done during the incumbency of Captain Smyser at the earnest request of his devoted wife. Services were conducted here by Reverend Chauncey W. Fitch, the post chaplain at Fort Wayne. The picture shows the little chapel decorated for a Christmas service, c. 1866. Dearborn pioneer Henry H. Haigh related, "I well remember helping, as well as a boy of 12 could, preparing the decoration." (Photograph courtesy Dearborn Historical Museum.)

This is a depiction of what the Powder Magazine looked like. Built in 1839, it was located 900 feet east of the arsenal complex. The building's walls were made over two feet thick as a precaution because of the powder kept within the structure. When the government closed the arsenal and sold the buildings, a local farmer, Nathaniel Ross, purchased the Powder Magazine and converted it into a private dwelling. The converted structure was donated to the city for use as a museum by the last family member that lived in the house, Mary Elizabeth Ross. (Photograph courtesy Dearborn Historical Museum.)

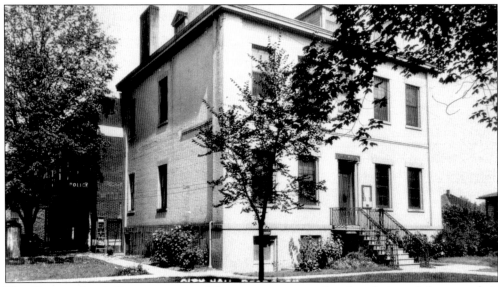

The Commandant's Quarters was used for many purposes after the closing of the arsenal. It became a multiple dwelling, jail, courthouse, the first local library, school, police station, and was also used for church activities. Seen here in 1928, it served as Dearborn City Hall. Today, it is a beautifully restored structure that is used as part of the Dearborn Historical Museum complex. (Photograph courtesy Dearborn Historical Museum.)

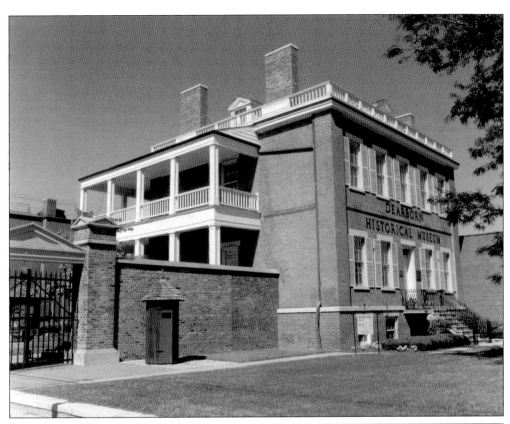

The Commandant's Quarters is the oldest building in Dearborn still standing in its original location. It served as home to the 19 commandants who headed the arsenal before it closed in 1875. This picture also shows the gateway to the arsenal grounds. (Photograph courtesy Dearborn Historical Museum.)

Colonel Joshua Howard (1793–1868), who had a long and honorable military service, served as an army officer in the War of 1812, was the officer in charge of the arsenal when it was under construction and was appointed the first commandant of the arsenal in 1833. He became lieutenant colonel in 1847 and served under President Abraham Lincoln as paymaster during the Civil War. He held state offices and was well known in Detroit business circles. He built what became known as the "Haigh Home" on the corner of Michigan Avenue and Haigh Street in 1834. It received its name when it was purchased by the Haigh family about 15 years later. (Photograph courtesy Dearborn Historical Museum.)

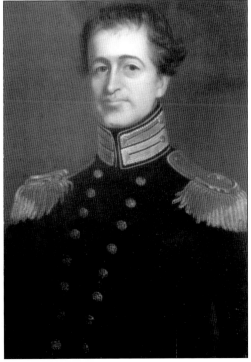

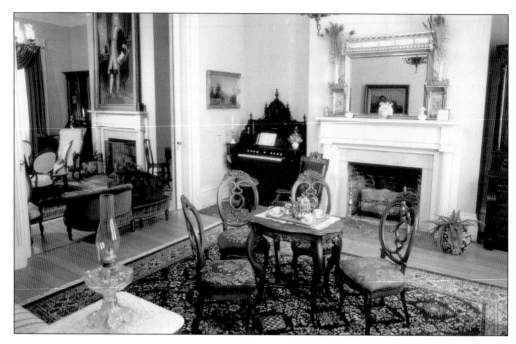

Now part of the Dearborn Historical Museum's complex, the building was opened to the public as Dearborn's first historical museum building in 1950. It has undergone numerous restorations and is used to teach visitors what life was like in the area during the mid-19th century. There are a number of period rooms that may be toured so that visitors can get a better feel for a bygone era of Dearborn's rich history. (Photograph courtesy Dearborn Historical Museum.)

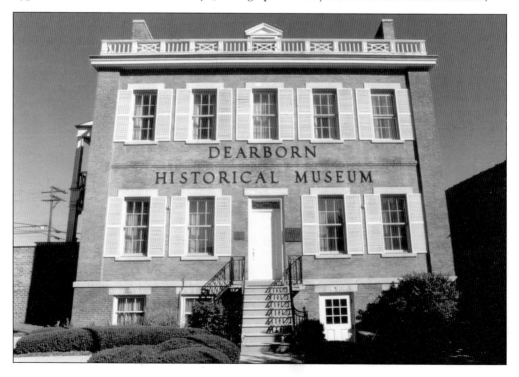

Three

RECOGNIZE THAT NAME?

EARLY LIFE AND SETTLERS

Names can be a unique part of a history lesson. The names of Dearborn streets, schools, and buildings can teach people about the past. They are significant because of their origin. Names speak of another era, another time, when settlers helped to build a village, a town, a city. This chapter will provide the reader with some names by which they can make a connection to where they live, as well as instill an interest in finding out more about the area. It is partly by recognizing names that one can come to appreciate the generations that came before and the foundations that have been laid in order to create the building blocks of the future.

The area on the south branch of the Rouge River, 10 miles from Detroit on the Great Sauk Trail, was originally named Dearbornville. The name was chosen by the arsenal's first commandant, Joshua Howard, in order to honor Major General Henry Dearborn, a Revolutionary War hero under whom Howard had served. Interestingly, the man for whom Dearborn was named never set foot in the area. In 1824, Governor of the Michigan Territory Lewis Cass, designated 144 square miles to be known as Bucklin Township, with Dearbornville as the area's southeastern border. In October of 1829, Bucklin Township was divided into two equal halves, the eastern half was named Pekin Township, the western half became known as Nankin Township. In March of 1833, Pekin Township was renamed Redford. Not long after, this area was split again which left two 36-square-mile areas. The northern portion remained Redford, while the southern portion became Dearborn Township.

What is today known as East Dearborn was established in 1818 as Springwells Township. The area was famous for its numerous natural springs. Those traveling along the Chicago Road would have found an inviting stop at the Schaefer Six Mile House near what is today the intersection of Michigan Avenue and Schaefer Road. To the northwest, in an area around the intersection of Ford and Greenfield Roads, was a small community called the Scotch Settlement, named this for the numerous Scottish or Scotch-Irish settling there. This is where Henry Ford, the famous industrialist, was born. In 1893, Dearborn Township was incorporated as the Village of Dearborn. The southeast portion of Dearborn was annexed to Springwells Township. Springwells' name was changed to Fordson (named after Henry Ford and son, Edsel) in 1925. Dearborn was incorporated as a city in 1927, and in 1929, Fordson and Dearborn were consolidated into one city, Dearborn.

As the reader scans the following text and images, many names, no doubt, will be familiar. (Note: There are also meaningful and recognizable names throughout the book.)

RAY H. ADAMS JUNIOR HIGH SCHOOL—dedicated in honor of former Superintendent of Schools, Ray H. Adams, retired in 1958.

CURTIS STREET—named for Leonard G. Curtis, surveyor of the M.J. Ford Estates Subdivision.

DONALDSON STREET—named for Ben R. Donaldson, director and advertiser at Ford Motor Company.

DUVALL SCHOOL—named for Leo DuVall, principal of the school from 1928 until 1959.

FORD ROAD—named for William Ford (1826–1905), father of Henry Ford.

FORDSON HIGH SCHOOL—named for Henry Ford and his son, Edsel.

GARRISON STREET—named for Charles M. Garrison (1837–1910), president of Detroit Board of Trade and land developer.

HENRY A. HAIGH SCHOOL—named for Henry A. Haigh, well-known farmer, financier, promoter, speaker, lawyer, and writer in area.

HOWE STREET—named for Elba D. Howe (1835–1912), one of Dearborn's pioneers, son of Elba Howe, station agent for the Michigan Central Railroad in Dearbornville, and community's first undertaker.

HOWE SCHOOL—named for Louis W. Howe, son of Elba Howe, served in many capacities in the community including following in his father's footsteps as a funeral director.

HOWARD STREET AND SCHOOL—named for Joshua Howard (1792–1868), first commandant at the Detroit Arsenal; postmaster; sheriff of Wayne County.

JEROME STREET—named for George Jerome, surveyor of Westland Subdivision; Village of Springwells engineer in early 1920s.

LAPHAM STREET—named for Abraham Lapham (1820–1888), landowner in the east and west ends of Dearborn.

LINDBERGH SCHOOL—named in honor of Charles A. Lindbergh, famous aviator; his mother attended the dedication.

LOWREY STREET AND SCHOOL—named for Harvey H. Lowrey (1878–1961), superintendent of the Springwells, Fordson, and Dearborn School districts, 1921–1946.

MAPLES SCHOOL—named for Fred E. Maples, served on Fordson Board of Education and family were pioneers in the Springwells-Fordson area.

MASON STREET—named for Stevens Thomson Mason (1811–1843), acting governor, 1835–1837; territorial "boy governor," and first governor of the State of Michigan, 1837–1839.

MORLEY STREET—named for Frederick Morley, Detroit newspaperman.

NEWMAN STREET—named for David Newman, land developer in the Dearborn area.

NOWLIN STREET AND SCHOOL—named for William Nowlin (1821–1889), pioneer in Dearborn and author of a first-hand account of Dearborn pioneer life, *The Bark Covered House*.

OAKMAN STREET—named for Robert Oakman, real estate developer of Aviation Subdivision.

SCHAEFER ROAD—named for Joseph Schaefer (1833–1897), Civil War veteran. Operated a hotel and tavern at Michigan and Schaefer.

SNOW ROAD AND SCHOOL—named for Dr. Edward Sparrow Snow (1820–1892), pioneer doctor in Dearborn and land owner.

STEADMAN STREET—named for Alice (Woodworth) Steadman, daughter of Alfred and Phoebe (Smith) Woodworth; wife of Albert Steadman.

STOUT JUNIOR HIGH SCHOOL—named for William Bushnell Stout, American aviation pioneer.

TERNES STREET—named for Albert P. Ternes (1870–1943), developer of the Albert P. Ternes Subdivision.

TIREMAN STREET—named for Joseph Tireman, farmer in Greenfield Township.

WHITMORE-BOLLES SCHOOL—named to honor two of Dearborn's families: J.E. Bolles, donor of the original site for the school, and Laura Whitmore Bolles, niece of William Nowlin and wife of J.E. Bolles.

WOODWORTH STREET AND SCHOOL—named for Alfred Woodworth (1818–1904), early pioneer farmer.

YINGER STREET—named for Floyd E. Yinger, mayor of Fordson, 1929. Chosen to fill vacancy of Joseph Karmann on Fordson Board of Education, June 1924–1928.

The early village and township that bore the name Dearborn were named in honor of this man, Major General Henry Dearborn (1751–1829). He served in many capacities during his career, including physician, minuteman in the American Revolution, and as an officer in General George Washington's army. Under President Thomas Jefferson, he was the secretary of war, and during the War of 1812, he was the senior major general of the army. At the request of the first commandant of the arsenal, Joshua Howard, who had served under General Dearborn, the area was named to honor this patriot and statesman. (Photograph courtesy Dearborn Historical Museum.)

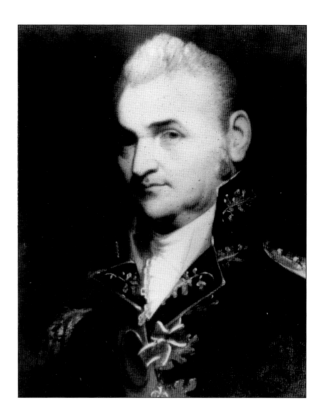

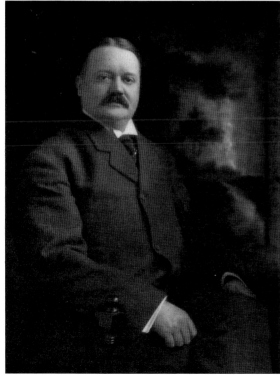

Henry A. Haigh, pictured here in 1906, was born in Dearborn in 1854. The son of Richard and Lucy Haigh, he was well-respected and well-liked throughout the community. He attended Michigan State University and the University of Michigan. He was truly a Renaissance man: a farmer, financier, promoter, speaker, lawyer, and writer. He helped to acquire railroad lines for Detroit to Cincinnati and Ypsilanti. He was a local historian and helped form the Dearborn Historical Commission, which led to the establishment of the Dearborn Historical Museum. He kept a diary of his life in the Dearborn area, which has been a great source of information for local historians. (Photograph courtesy Dearborn Historical Museum.)

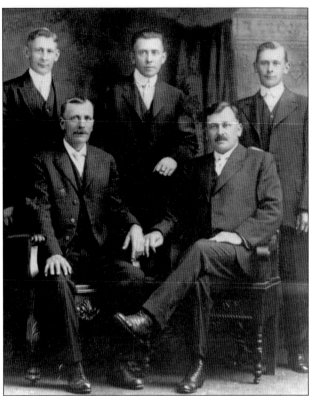

As one of the early families to settle in the area, the Esper name is well-known in Dearborn. Pictured, from left to right, are the five sons of Anthony and Elizabeth (Reuter) Esper: Aloysius, Bernard (later city clerk for Fordson and Dearborn), Anthony (later councilman from 1929–1948), Francis, and Joseph. Their grandfather was Peter Esper, who was among the early pioneers. Peter and his family came from Germany in 1842 and settled in what is known today as East Dearborn. (Photograph courtesy Dearborn Historical Museum.)

The family gathers to enjoy a picnic on the farm of Anthony Esper around the year 1901. The farm was located on what is today Warren Avenue and Calhoun Street.

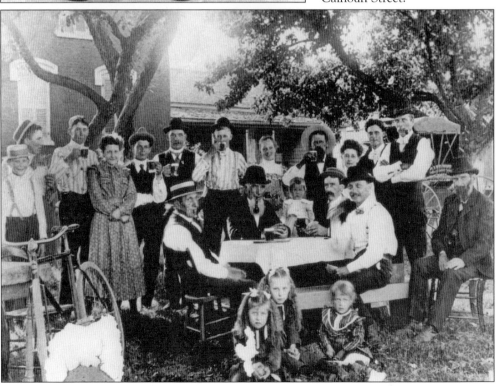

William Daly (1819–1901) came to Dearborn Township in 1842 and served in numerous capacities for the area. He became superintendent of the poor in Wayne County and supervised the county asylum. He also held the offices of highway commissioner and justice of the peace. Daly, by cutting timber and hauling it himself, helped build the first Catholic Church (Sacred Heart) in what is now west Dearborn. (Photograph courtesy Dearborn Historical Museum.)

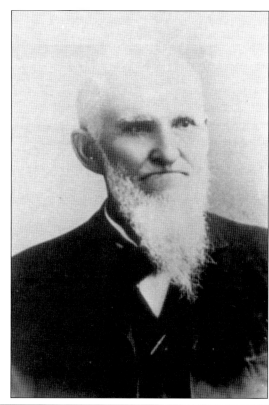

This is a very unique image of how wool was washed on the farm of William Daly. Most people think of the sheep being sheared first, but this picture shows the sheep getting a good bath in the Rouge River before being sheared. The picture was taken around 1894. (Photograph courtesy Dearborn Historical Museum.)

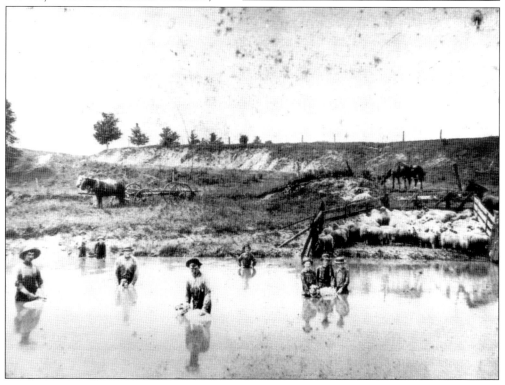

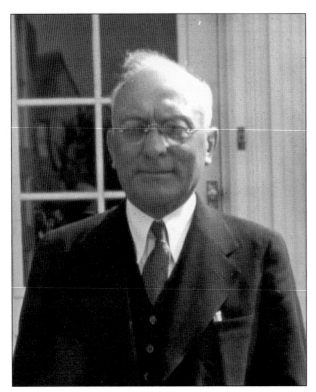

John S. Haggerty, pictured here on his 50th birthday, was one of the most influential political figures to ever come from the Dearborn area. He was instrumental in adopting concrete roads in Wayne County. Haggerty served on the Wayne County Road Commission for 27 years and his name became synonymous with "good" roads, otherwise known as concrete roads. (Photograph courtesy Dearborn Historical Museum.)

Charles T. Horger (1879–1936) was born in Springwells Township. The Horger family was one of the earliest to settle in this region. He worked his way up from township treasurer to township supervisor and became the first president of the recently incorporated Village of Springwells in 1921. During his tenure, he helped the village receive city status. He also helped to establish the beautiful, brick city hall on Michigan Avenue and Schaefer that still serves as Dearborn City Hall. (Photograph courtesy Dearborn Historical Museum.)

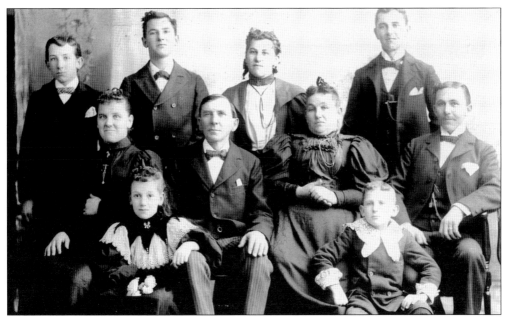

Albert Ternes was involved in the consolidation of Dearborn and Fordson, and served on the Consolidation Committee that was appointed to study the matter. Pictured here, from left to right, are the following: (standing) George Ternes, William Ternes, Theresa Ternes Carlen, Albert Ternes; (seated) Margaret Ternes Nichel, Mr. Antony Ternes, Mrs. Mary Horger Ternes, Frank Anthony Ternes; (on the floor) Della Ternes Connelly and Frederick Ternes. (Photograph courtesy Dearborn Historical Museum.)

Another pioneer family, the Reuters, are pictured in this 1918 photograph, from left to right: (standing) Veronica (Esper) Horger and Alma Horger; (seated) Frank Reuter and Elizabeth Reuter Esper. Note that the school at left is possibly St. Alphonsus. The Esper home was at Warren and Catherine. (Photograph courtesy Dearborn Historical Museum.)

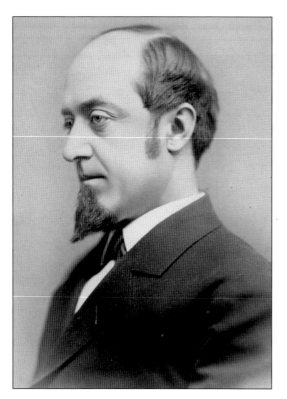

Pictured here on October 31, 1866, is Charles Garrison, an early settler for whom Garrison Street was named. (Photograph courtesy Dearborn Historical Museum.)

Abraham Lapham (1819–1888) and Ruth Ann (Hall) Lapham (1833–1889) pose here in the 1880s. The Lapham family owned a 100-acre farm on what is currently the corner of Military and Monroe Streets. They also operated a general store and butcher shop. Their son, David P. Lapham, established the first bank in Dearborn in 1896. (Photograph courtesy Dearborn Historical Museum.)

After the arsenal was closed in 1875, the buildings were auctioned off. The building that had served as the powder magazine was sold to Nathaniel Ross in 1882. He transformed the structure into a private dwelling. Mary Elizabeth "Lizzie" Ross, pictured here, was the last resident of the home. She willed the home, land, outbuildings, and all her worldly possessions to the City of Dearborn to be used as a museum. She passed away in 1950 and the museum was first opened in 1956. (Photograph courtesy Dearborn Historical Museum.)

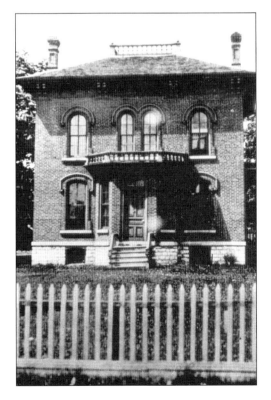

The Woodworth House, built in 1868, was occupied by Alfred Woodworth and his family, early settlers in what is now East Dearborn (today, the northwest corner of Michigan Avenue and Ternes). In 1832, when Alfred was 14, his family settled in what was then Greenfield Township, and built a log cabin on the site of present-day Woodworth School. At one point, his farm grew to 245 acres. The house pictured here was a restaurant for a while until it was razed in 1981. (Photograph courtesy Dearborn Historical Museum.)

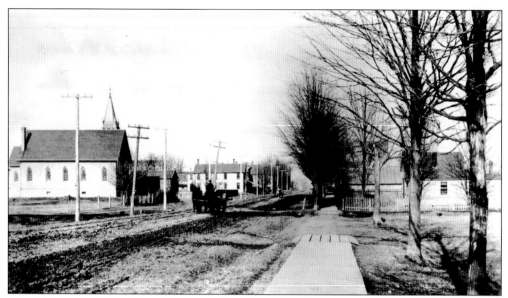

The little town of Dearbornville was still a peaceful, quiet, agrarian area in the 1890s. This would change shortly, as industrialization and Henry Ford would soon be arriving on the doorstep. The church on the left is the Ten Eyck Memorial Methodist Church. (Photograph courtesy Dearborn Historical Museum.)

People from Dearborn have always had a passion for the history of the area and have dedicated themselves to building better lives. Pictured here are some early settlers, and though there are too many to individually identify, the group consists of many names that are still familiar today: Davenport, Garfield, Haigh, Gulley, and Howe. (Photograph courtesy Dearborn Historical Museum.)

Four

STRUCTURES

PAST AND PRESENT

The lives of human beings revolve around buildings. Various structures through the years have been used for homes, businesses, government, entertainment, education, and any use man has found the need for. The log cabin served as the early home in the Dearborn area. A good example of this was the cabin that the Nowlins built when they first arrived in 1834 (see drawing on page 13). Another example of an early home in Dearborn is the Gardner House, a frame structure that was built in 1831 and is now part of the Dearborn Historical Museum complex. It was originally located near Warren and Southfield and is presently the oldest building still standing in Dearborn. If a settler had livestock, a log barn had to be built to house them in the cold weather. In the days of the early settlers, one of the first buildings to be put up in a town or village (provided it was located by a river) was a sawmill. Gristmills were also important. One of the first gristmills erected in the Dearborn area was Coon's Mill, located on the Rouge River close to Outer Drive between Ford Road and Warren.

As the population grew, so did the number of structures that served the settlers' needs: general stores, dry goods stores, clothing stores, hardware stores, banks, schools, and churches. According to the 1839 *Gazetteer of the State of Michigan*, by 1839, Dearbornville had "a church for Methodists, a sawmill with double saws, flour mill, with two run of stones, 7 stores, 2 smitheries, and a foundry for iron, propelled by horse power, a physician, and about 60 families." One of the first known schoolhouses, built in 1824, was called the Little Red Schoolhouse or Wallaceville School (located on today's Gulley Road). Another early schoolhouse was the Miller School, built in 1830 at Michigan and Miller Road. A small congregation of people organized the first church in Dearborn in 1810, and by 1818, they had built a log cabin church 120 yards north of the Rouge River, east of what is today Greenfield Road (a historical sign marks the location on Butler Road).

A famous stagecoach stop on the Chicago Road (the old Sauk Trail) was the Ten Eyck Tavern. The tavern stood near the present bridge that crosses the Rouge River on Michigan Avenue. The structure was built in 1826 and was often filled to capacity with westbound travelers who needed a good meal and a night's sleep before continuing on the road. The area continued to grow as the arsenal, railroads, and improved roads all brought more settlers and more change. The ability to travel by train brought more people, not necessarily to settle, but passing through on their journey west. This brought the need for accommodations and refreshments. Hotels such as the Dearborn Hotel sprung up near the railroad tracks to serve those riding by train.

The first private mental facility in Michigan, St. Joseph's Retreat, was built in Dearborn in

1885 by Sister DeSales Tyler. It was located on the northeast corner of Michigan and Outer Drive. A.B. Gulley, a Dearborn farmer, built his home on Michigan Avenue just east of Gulley Road in 1859. The farmhouse served as a home for orphaned and disadvantaged boys from 1911 until 1916. From 1918 until 1955, it was used as a home for wayward and unfortunate girls. Today, portions of the original structure have been incorporated into the Elks Club of Dearborn.

It was industrialization, and specifically the automobile industry, that brought rapid change to Dearborn. With the consolidation of Fordson and Dearborn, the result was a single city of 50,000 people. Connected with this change, structures that affected people's lives were built in the early 20th century. The River Rouge Plant—what would become the largest industrial complex in the world—was built in 1917 and continued to expand into the 1930s. The Ford Rotunda was actually built as an exhibit for the 1933–34 Chicago World's Fair. In 1935, Henry Ford had the building moved to Dearborn. It was a tremendously popular attraction with exhibits that covered every facet of the Ford Motor Company. At Christmas, the building was filled with awesome displays that turned the entire complex into a fairytale land. The Ford Motor Company World Headquarters was completed in 1956.

There have been numerous significant structures in Dearborn that have, in one way or another, impacted the lives of residents: the magnificent city hall, the Dearborn Inn, the first airport/hotel, the Edison Institute (Henry Ford Museum and Greenfield Village), libraries, and Camp Dearborn. While not technically a structure of brick and mortar, Camp Dearborn was created for the citizens and has meant so much to the residents through the years, and therefore deserves to be included in this chapter. While the list above is by no means comprehensive, it does give a sense of how Dearborn grew from a small rural village to an industrialized city with numerous impressive structures that have served the citizens well. The following images will help tell the story of many of these Dearborn buildings.

Opposite: The Ten Eyck Tavern, another early pioneer inn, was built in 1826 on the Chicago Road (Michigan Avenue) close to the Rouge River. It was a day's journey from Detroit, and weary travelers were welcomed by proprietor Conrad Ten Eyck, cheerfully and with good humor. It is said this is where Michigan received the nickname "Wolverine State," for when Conrad would joke to a patron about eating "wolf steaks," some travelers replied that they must be "wolverines" if they were going to be eating wolf. Often, the inn was crowded to the point where many had to sleep on the floor. The arrival of the railroad caused a drop in visitors to taverns like Ten Eycks, because the line took the folks right past it. The Ten Eyck Tavern was used to store grain until it burned down in 1885. (Photograph courtesy Dearborn Historical Museum.)

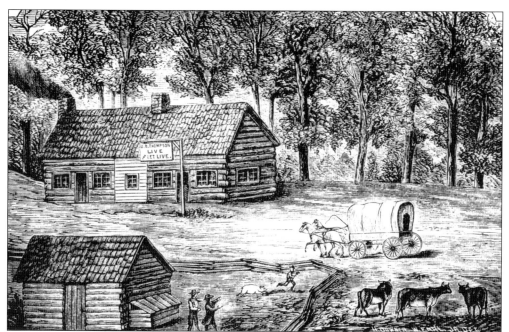

Early on, transportation was a major problem. The opening of the Erie Canal brought an influx of settlers and travelers. However, the roads leading to the interior were in many cases barely passable. A welcome site on the trail would have been a tavern providing a warm place to spend the night and enjoy some food and drink. One of the first in the Dearborn area was Thompson's Tavern, erected in 1834 on the grounds of the arsenal at Michigan Avenue and Oakwood. This tavern was perfectly located because it could also service the soldiers stationed at the arsenal. (Photograph courtesy Dearborn Historical Museum.)

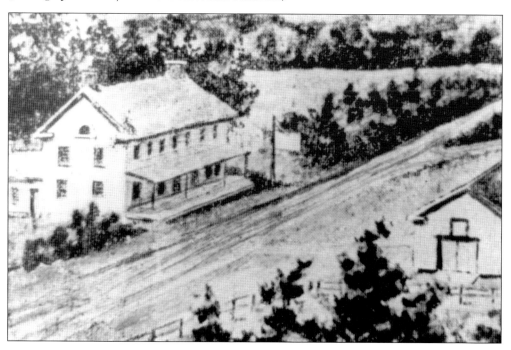

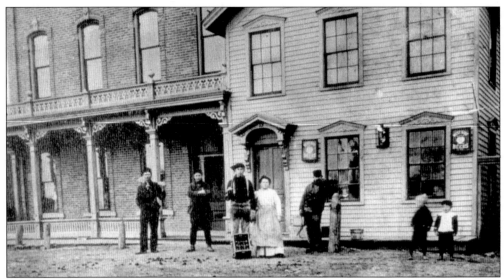

This structure was known as the Schaefer Six Mile House, built by Joseph Schaefer in 1864, on what is now the northeast corner of Michigan Avenue and Schaefer. Years later, the tavern was operated by his son, John, until 1918. Pictured from left to right are the following: Al Founder, carpenter; Frank Schaefer; the house keeper and handyman (names unknown); Joseph Schaefer, with ice tongs; children are Joseph Schaefer, son of John Schaefer, and Joseph W. Schaefer. The inn was called the Six Mile House because it was six miles from the Detroit City Hall. (Photograph courtesy Dearborn Historical Museum.)

Papke's Tavern, another early inn, was built on the present southeast corner of Michigan Avenue and Monroe. It was also known as the 10 mile house because it was 10 miles from Detroit City Hall. As was custom in early taverns, meals were free and the latest news or gossip flowed freely in the laid-back atmosphere. These businesses served a very important function in the early days of the pioneers and stagecoach travel. (Photograph courtesy Dearborn Historical Museum.)

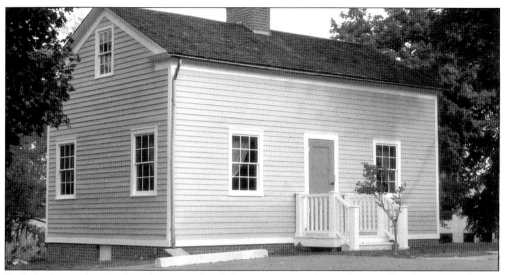

Built in 1831, the Gardner house is the oldest structure still standing in Dearborn. The house was originally located near present-day Warren Avenue and Southfield Road. The Gardners were well-known in the area for the English draft horses they raised. The building was purchased by Henry Ford and moved to Greenfield Village in 1929. The home stood there until 1996 when it was moved to the premises of the Dearborn Historical Museum (McFadden-Ross House) where it is used to teach visitors about pioneer life in the Dearborn area and what it was like to live in a simple, rural farmhouse such as the Gardner house. (Photograph courtesy Dearborn Historical Museum.)

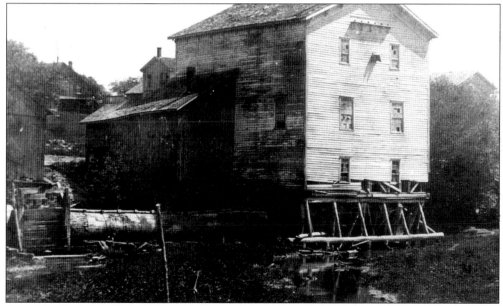

Coon's Mill was erected prior to 1850. It was located on Outer Drive between Ford Road and Warren Avenue, 1.5 blocks from Ann Arbor Trail. The first owner was Joseph Coon, who was born in 1814 and died in 1889. This gristmill was used by area settlers and was a great resource in order to have their grain transformed into much-needed flour. The building was razed when the property was purchased by Henry Ford. (Photograph courtesy Dearborn Historical Museum.)

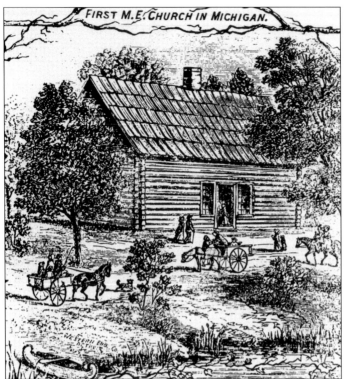

In 1810, a small number of charter members officially organized the first Methodist Episcopal Church of Michigan. For a number of years, services were held in the private homes of members. In 1818, a log cabin church was built on the north side of the Rouge River in the township of Dearborn. In 1943, this structure burned to the ground. Today, a historical marker notes the original location on Butler Road just east of Greenfield Road. This congregation still exists today as the First United Methodist Church of Dearborn. (Photograph courtesy Dearborn Historical Museum.)

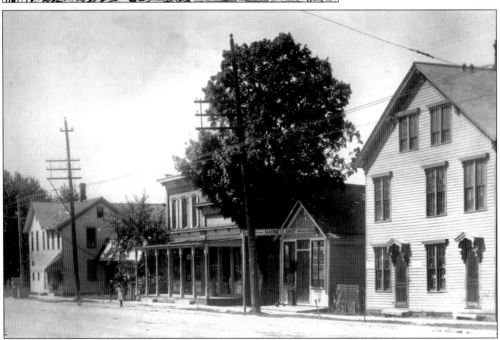

Pictured here in 1906 are some of the businesses that lined the north side of Michigan Avenue in what is known today as West Dearborn. From left to right are Maurer's Saloon, William Shultz's Grocery, Herman Blankertz's Harness Shop, and Michael McFadden's General Store. (Photograph courtesy Dearborn Historical Museum.)

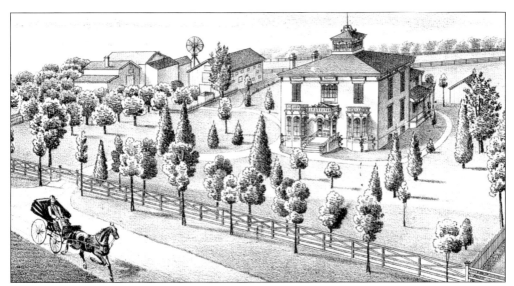

This is a depiction of the home built by A.B. Gulley, a Dearborn resident and farmer, in 1859 on Michigan Avenue just east of what is today Gulley Road. Henry Ford purchased the property and home and offered it as a summer camp for boys. In time, the building became a home for boys 12–18, who had lost one or both parents, had been abandoned, or whose parents were unable to take care of them. From 1918 until 1955, it was used as a home for wayward girls. Today, part of the original structure has been incorporated into the Dearborn Elks Lodge. (Photograph courtesy Dearborn Historical Museum.)

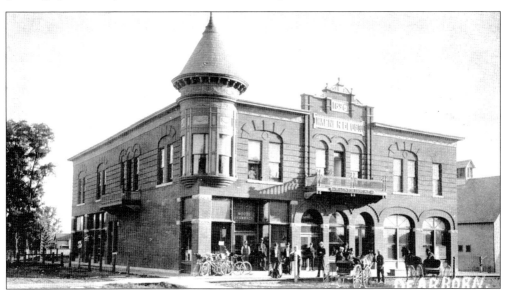

The Wagner Hotel was erected in 1896 on the southwest corner of Michigan Avenue and Monroe by Anthony Wagner and his son, Charles. The 28-room building was constructed with bricks from the Wagner brickyard. A large water tank on the roof supplied running water to the patrons. The hotel closed in the 1920s, and the structure was used for various businesses throughout the years, including Dearborn's post office. The building still stands and its unique tower has become somewhat of a landmark in present-day Dearborn. (Photograph courtesy Dearborn Historical Museum.)

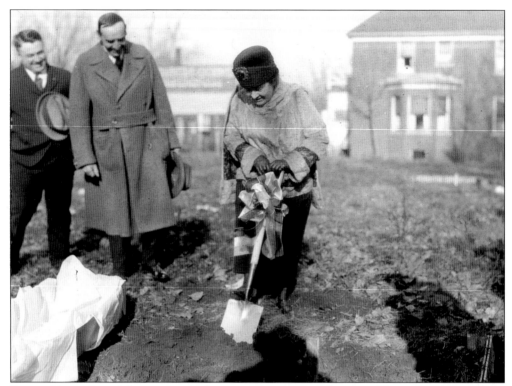

Pictured here, from left to right, at the groundbreaking of the main library (now the Bryant Library located on Michigan Avenue) on November 20, 1923 are Clyde Ford, Clarence Parker, and Clara Ford with shovel. (Photograph courtesy Dearborn Historical Museum.)

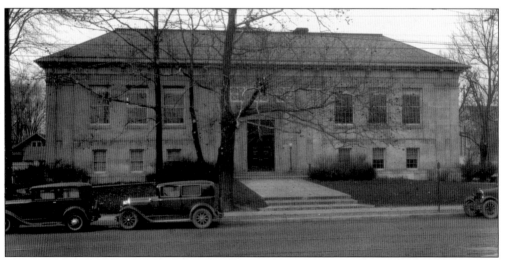

This library, at Mason and Michigan Avenue, was originally the main library in Dearborn. Clara Ford, Henry's wife, helped with the groundbreaking ceremony. The building opened on November 25, 1924. In November 1969, the Henry Ford Centennial Library opened and the old main library became known as the "Mason Branch." In April 1977, the Mason Branch was renamed the "Bryant Branch" in honor of Katharine Bryant, library commissioner. (Photograph courtesy Dearborn Historical Museum.)

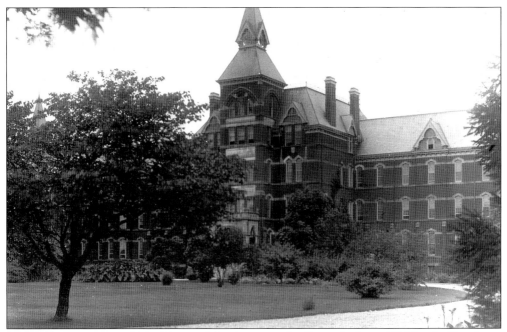

St. Joseph's Retreat, a 400-bed hospital for the mentally ill, was built in 1885 by the Daughters of Charity of St. Vincent De Paul on 140 acres of land at the present-day northeast corner of Michigan Avenue and Outer Drive. It was Michigan's first private mental institution. The first patients were Civil War veterans, and later, alcoholics and drug addicts. Other patients with curable conditions were treated here as well. Time and wear took a toll on the structure, and it was decided that new types of treatment had made the structure obsolete. In 1962, the retreat was closed and the impressive building razed. (Photograph courtesy Dearborn Historical Museum.)

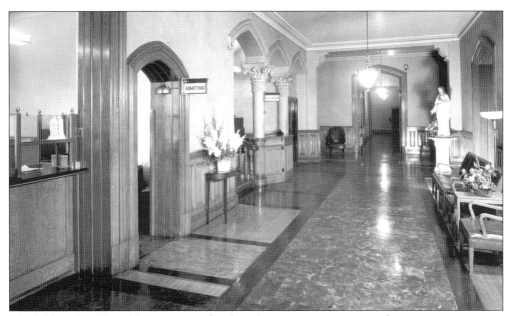

The lobby of St. Joseph's Retreat used rich architecture to create a welcoming environment. (Photograph courtesy Dearborn Historical Museum.)

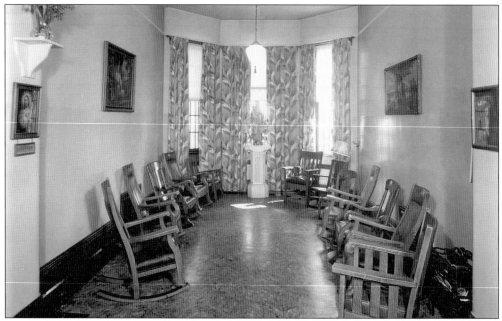

Pictured here is the interior of St. Joseph's Retreat. There were pleasant places for patients to lounge throughout the building. (Photograph courtesy Dearborn Historical Museum.)

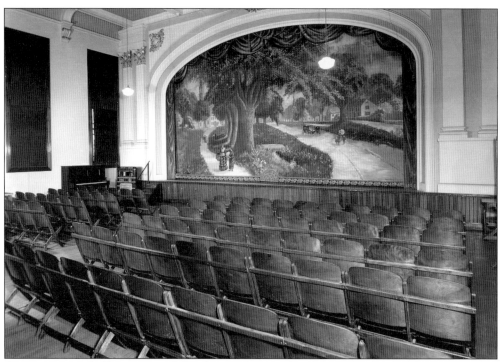

An amusement hall was created for the patients at the retreat. Patients took part in plays, tea parties, games, billiards, and music in the parlors and recreation rooms. The grounds were extensive with a large apple orchard serving as the chief recreational ground for the patients. (Photograph courtesy Dearborn Historical Museum.)

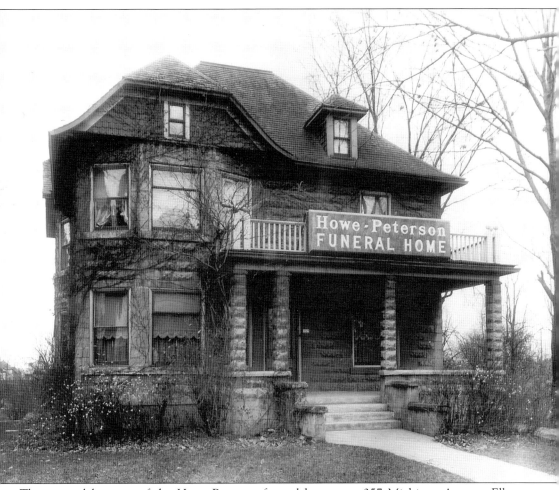

The original location of the Howe-Peterson funeral home was 357 Michigan Avenue. Elba Howe was a station agent for the Michigan Central Railroad in Dearbornville and became the community's first undertaker. His son, Louis Howe, was born in 1873 and served as township clerk, treasurer, volunteer fire chief, insurance salesman, and followed in his father's footsteps in the funeral business. (Photograph courtesy Dearborn Historical Museum.)

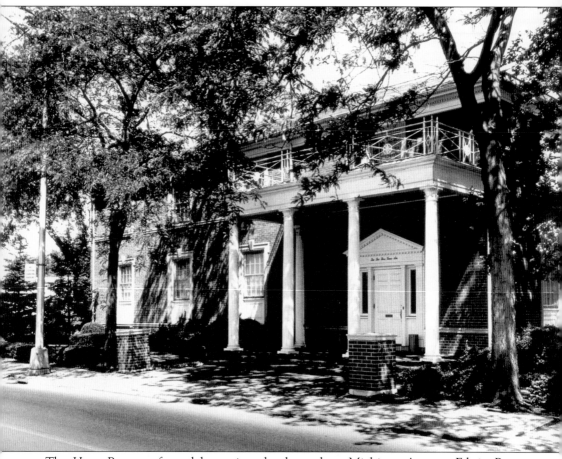

The Howe-Peterson funeral home is today located on Michigan Avenue. Edwin Peterson partnered with Louis Howe in 1927. In the early 1950s, Peterson bought Howe's share of the business and continued to run the funeral parlor with Howe's name. It has remained Howe-Peterson to the present. (Photograph courtesy Dearborn Historical Museum.)

Opposite, Top: Pictured here is the dedication of the new city hall in Springwells Township in June of 1922. The beautiful colonial structure was and is considered one of the finest in the country. The dedication was festive, with balloons and candy, as well as a visit from two aviators who circled the area distributing bags of certificates that could be turned in for cash prizes. (Photograph courtesy Dearborn Historical Museum.)

Opposite, Middle: When Fordson and Dearborn merged to form one city, this impressive structure became Dearborn City Hall, shown here in the 1930s at the corner of Michigan Avenue between Maple and Schaefer. Notice the tracks; transportation by an electric car known as the interurban started in Dearborn in 1897. The first streetcars appeared in Fordson (now East Dearborn) in 1928. (Photograph courtesy Dearborn Historical Museum.)

Opposite, Bottom: The home of Ford Motor Company's World Headquarters was completed in 1956. The structure is a 12-story central office building and a 2-story penthouse. At the rear of the building is a service unit that contains dinning rooms, cafeteria, barber shop, and other employee maintenance facilities. The office building is located on a 90-acre site and is often referred to as "The Glass House" around Dearborn. The building rises 200 feet in height and has nearly 5 acres of glass on the exterior and interior. (Photograph courtesy Dearborn Historical Museum.)

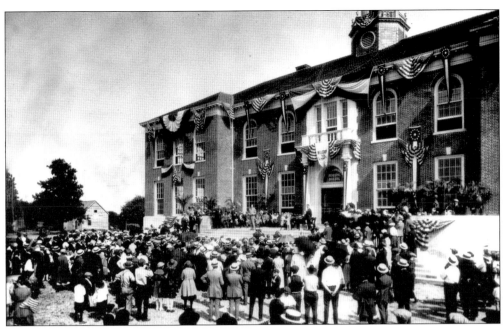

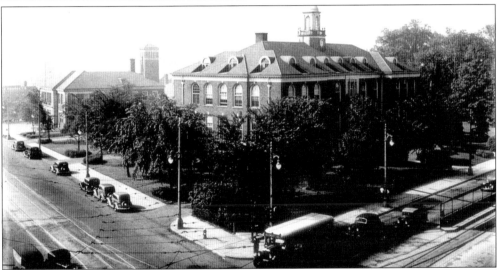

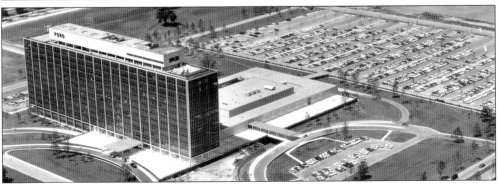

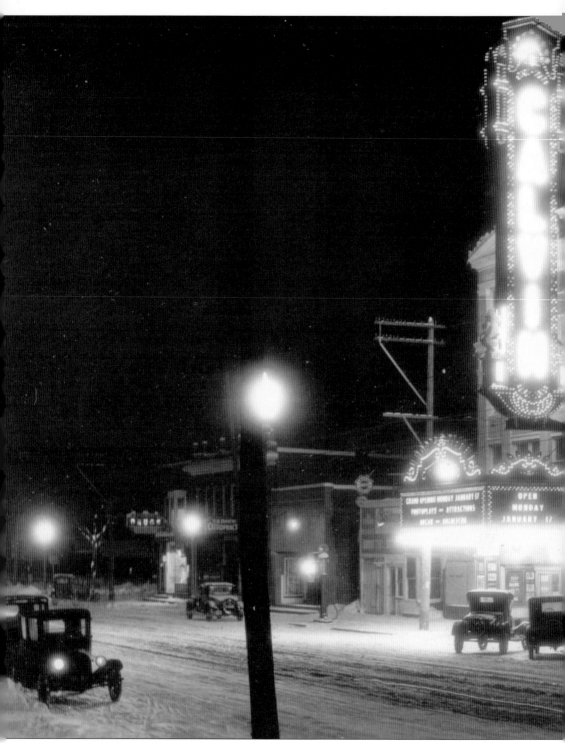

The beautiful Calvin Theater was located on Michigan Avenue (West Dearborn) where the Ten Eyck Memorial Methodist-Episcopal Church once stood. The opening night was on January 17, 1927. The Calvin was used for first-rate films such as *Gone with the Wind*, plays,

and functions such as political rallies. Many Dearbornites will remember some good times at the Calvin. (Photograph courtesy Dearborn Historical Museum.)

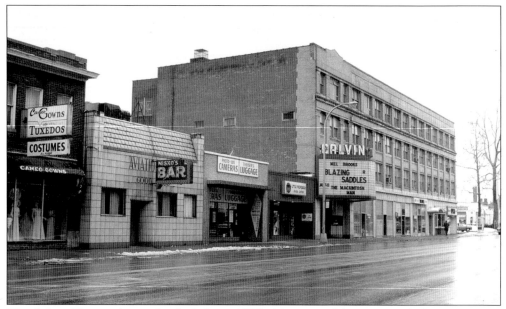

The Calvin Theater during the daylight in 1975. After several fires occurred, the interior was left gutted and the building was torn down in 1981. (Photograph courtesy Dearborn Historical Museum.)

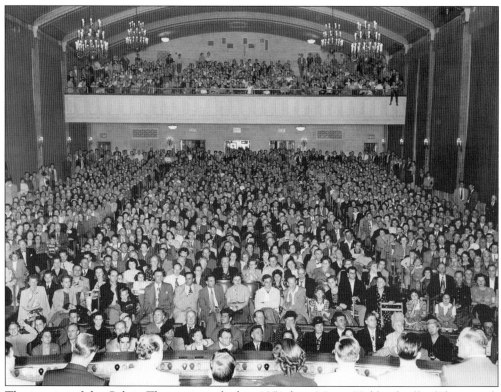

The interior of the Calvin Theater is packed in 1951 for a Mayor Hubbard rally. (Photograph courtesy Dearborn Historical Museum.)

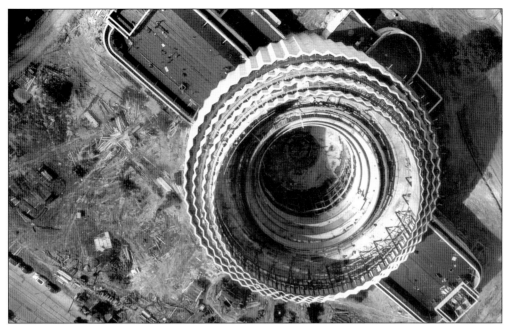

The Ford Rotunda was designed and built for the 1933–34 Chicago World's Fair. The structure rose 12 stories in a gear-shaped formation and was staffed by 800 Ford employees. The exhibits, according to Henry Ford, were designed to show people "how we do things" at Ford Motor Company. It drew high praise in Chicago and was visited by over 12 million people. This picture shows the rotunda under construction in Chicago. (Photograph courtesy Dearborn Historical Museum.)

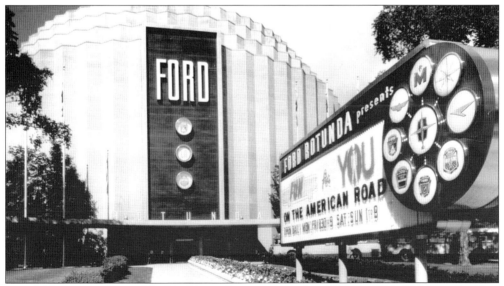

Pictured here is the front of the Ford Rotunda as it appeared in 1958. In 1935–36, Henry Ford had the building moved to Dearborn and placed across from the Ford Motor Company's Administration building on Schaefer Road. It was the largest permanent industrial exhibit building in the country and was used as a reception area and orientation point for thousands of people who annually took tours of the Rouge Plant. (Photograph courtesy Dearborn Historical Museum.)

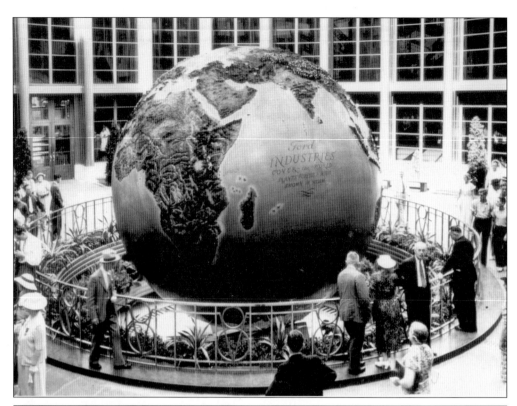

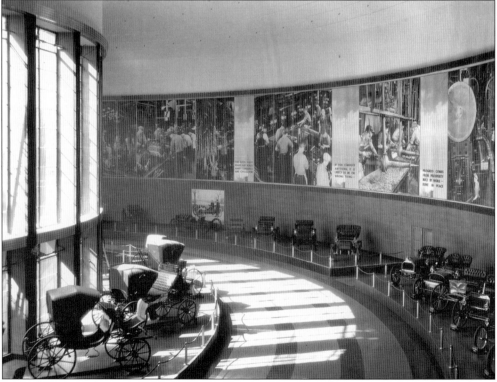

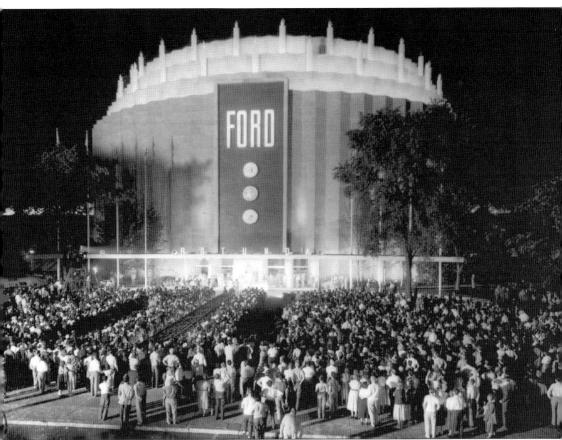

The Ford Rotunda was opened to the public on May 16, 1936. The building housed a display area for new cars, an exhibit hall, and a 388-seat theater. Animated exhibits demonstrated how raw materials were brought to the Rouge Plant. Next to the building, there was a roads-of-the-world exhibit, a reproduction of 19 historic roads of the world linked together. The Ford Rotunda attracted visitors from the Detroit area and from all over the world. The first year, over 900,000 people came, and in turn, the number of visitors to the Rouge Plant increased to an all-time high. (Photograph courtesy Dearborn Historical Museum.)

Opposite, Top: The Ford Rotunda housed a huge revolving globe in the center of the building. Having only the sky for a roof, the colored and shaded markings of the globe highlighted various Ford interests around the world. The words on the globe proclaim: "Ford Industries Cover the World." (Photograph courtesy Dearborn Historical Museum.)

Opposite, Bottom: Around the wall in the courtyard was a gigantic photo mural that described manufacturing and assembly processes at the Rouge Plant. Note in the back Henry Ford's Racer "999" and above it, a large photo of Henry Ford and Barney Oldfield. The racer had been used by Ford to promote his company and he even raced it himself to a world-record 92 miles an hour on frozen Lake St. Clair in 1903. (Photograph courtesy Dearborn Historical Museum.)

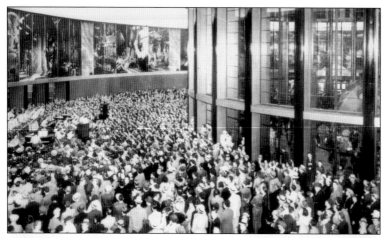

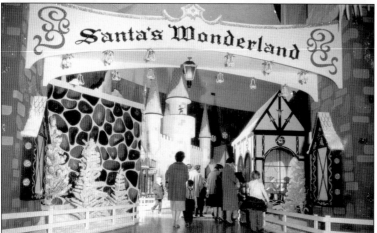

The Ford Rotunda had a tremendous Christmas display and holiday programs every year. From 1953 until 1961, the building was set up for what was dubbed the "Christmas Fantasy Display." Highlights included decorations that demonstrated how Christmas had been celebrated throughout America's past, an enormous doll collection, choirs singing carols, and, of course, Santa Claus. (Photograph courtesy Dearborn Historical Museum.)

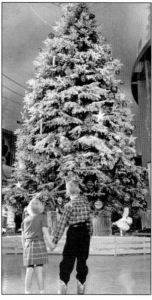

Pictured far left is a Christmas scene at the Ford Rotunda in 1957. In addition to the amazing Christmas display, small visitors had a chance to sit on Santa's lap to tell him what would be great to see under the tree on Christmas day. To the immediate left is a picture of the annual Rotunda Christmas Tree in 1957. (Photograph courtesy Dearborn Historical Museum.)

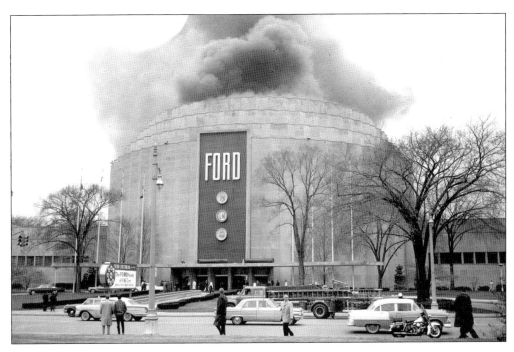

Pictured is a view of smoke billowing up from the flames (above) and another of the wreckage after the fire that destroyed the Rotunda building on Friday, November 9, 1962 (below). The fire started on the roof, which was being retarred at the time. The flames spread so fast there was no way to save the building. Today, a building that brought so much joy to so many, including many Dearbornites, still lives in the hearts and minds of those who experienced this incredible structure. (Photograph courtesy Dearborn Historical Museum.)

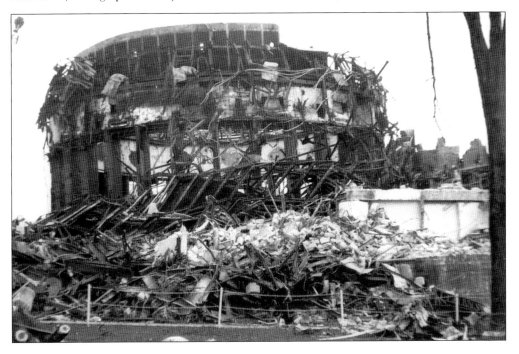

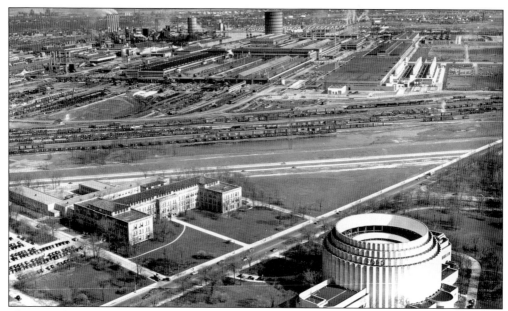

This aerial view of the Ford Motor Company's huge manufacturing area shows the Rouge plant in the background, and the famous Ford Rotunda and the administration building in the foreground. The 2-square-mile industrial area includes blast furnaces, steel mills, a production foundry, press steel operations, a motor factory, a final assembly, and other operations. Rouge buildings were designed with more than 15,767,700 square feet of floor area and contain 120 miles of conveyors. There are more than 100 miles of railroad in the Rouge complex. (Photograph courtesy Dearborn Historical Museum.)

One important aspect of the Ford Rouge Plant involves steel: from ore pits to blast furnaces to open hearth furnaces to the rolling mill, Ford-manufactured steel was used in all Ford cars and trucks. (Photograph courtesy Dearborn Historical Museum.)

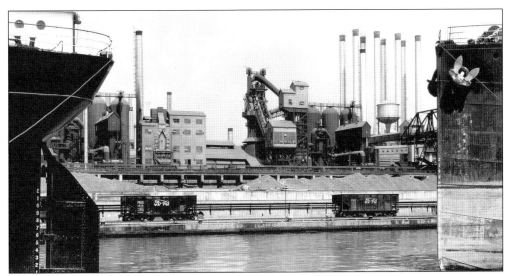

This is Main Gate #4 to Ford Motor off Miller Road To service the Rouge Plant and its 1.3 miles of docks, 92 miles of railway track were laid. Here, Ford ships and other Great Lakes freighters brought in great cargos of iron ore, coal, limestone, and lumber in the manufacture of Ford cars and trucks. The storage bins had a capacity of 2 million tons. (Photograph courtesy Dearborn Historical Museum.)

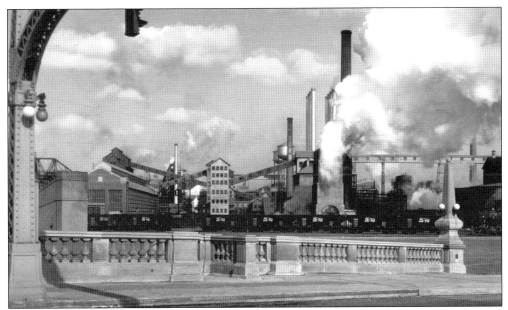

Operations started in 1917, and this is how the Ford Rouge Plant appeared in 1932. In 1999, Bill Ford Jr., then Chairman of the Board of Ford Motor Company and now CEO, introduced a plan to overhaul the entire Rouge complex. The overhaul will include an innovative assembly plant to produce Ford trucks. Flexibility will be built into the system with the capability of handling three different vehicle platforms and nine different models. The roof of the new assembly plant will be environmentally friendly with a covering of an ivy-like plant that will have a number of benefits. New life is being breathed into the Rouge complex that has served Ford Motor so well for so long. (Photograph courtesy Dearborn Historical Museum.)

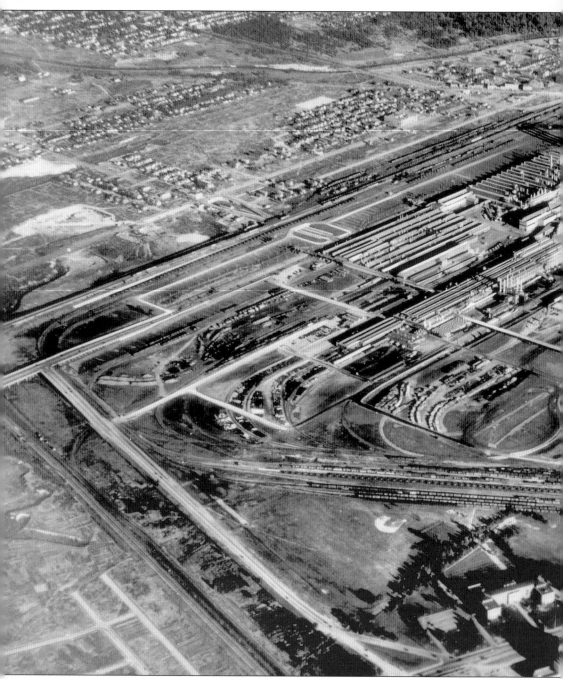

By the late 1920s, the Ford Rouge Plant had become the largest industrial complex in the world with 93 structures, 90 miles of railroad tracks, 27 miles of conveyors, 53,000 machine tools, and 75,000 employees. Noted Detroit architect Albert Kahn designed most of the complex. One writer observed that "this monument of Ford is more awesome than the mightiest sights of nature for the reason that it is man-made. It looks like the ultimate, even in an age that is accustomed to feast on the big and the spectacular." The complex was designed to take in raw materials in one end and transform those materials into a finished automobile. The process was and still is

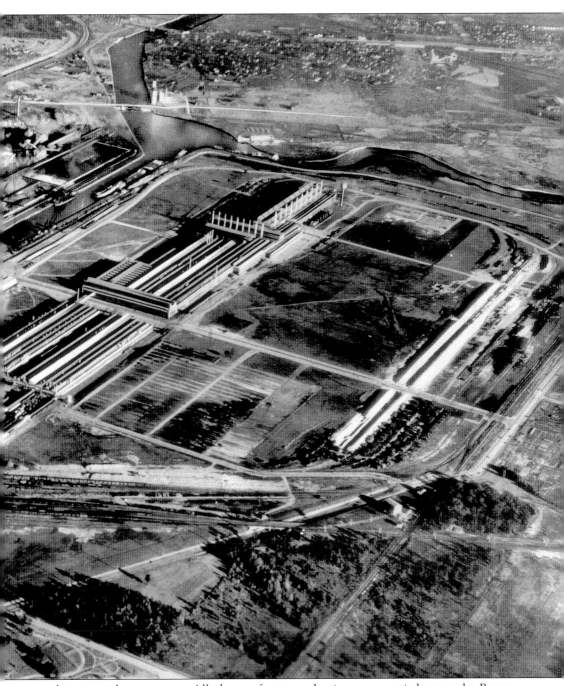

a complex one with many steps. All phases of auto production were carried out at the Rouge complex: iron ore delivery by ship or rail, steel forging, stamping operations, manufacturing of parts, and assembly of automobiles. The complex had its own power plant, glass plant, cement plant, and by-products plant, which produced paints, fertilizers, and charcoal. While not all of these phases are in operation today, the facility still consists of the Dearborn Engine and Fuel Tank Plant, Frame Plant, Tool and Die Plant, and Glass Plant. These plants supply 16 assembly plants. (Photograph courtesy Dearborn Historical Museum.)

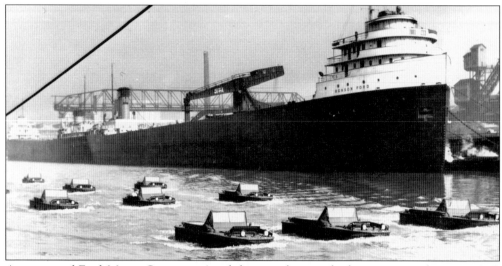

A convoy of Ford Motor Company Amphibious military vehicles get a test drive in 1945. The Rouge Plant produced numerous war materials for World War II: jeeps, trucks, tanks and tank destroyers, amphibian jeeps, armored cars, universal carriers, and jet bomb engines. (Photograph courtesy Dearborn Historical Museum.)

Pictured on the left are folks with their tent at Camp Dearborn on July 13, 1950. It was 36 miles from Dearborn to Camp Dearborn, but that did not seem to affect the popularity of the attraction. On the opening weekend, Memorial Day Weekend, 1948, 2,500 people flocked to the camp. The facility quickly became one of the favorite destinations of Dearbornites. On the Fourth of July weekend, there were 7,000 visitors. (Photograph courtesy Dearborn Historical Museum.)

Visitors enjoy a bonfire and singing at Tent Village in Camp Dearborn in 1958. (Photograph courtesy Dearborn Historical Museum.)

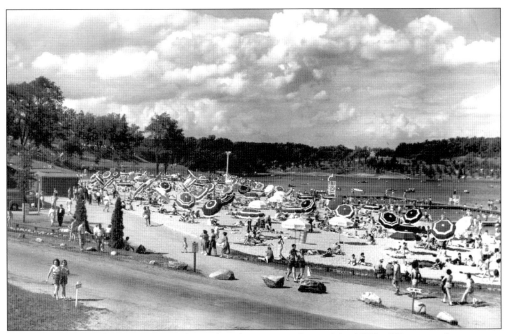

Pictured here is the Camp Dearborn beach area on June 11, 1950. (Photograph courtesy Dearborn Historical Museum.)

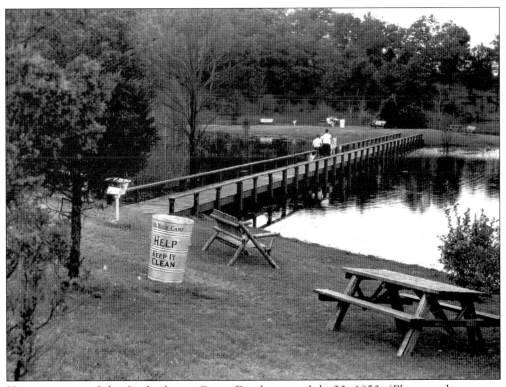

Here is a view of the footbridge at Camp Dearborn on July 30, 1950. (Photograph courtesy Dearborn Historical Museum.)

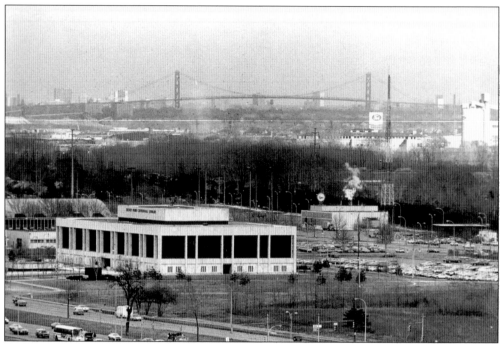

On a very clear day such as March 25, 1979, the view from the top of the Hyatt Regency is amazing. One can see the Henry Ford Centennial Library, Ford Rouge Plant, Ambassador Bridge, and downtown Detroit. (Photograph courtesy Dearborn Historical Museum.)

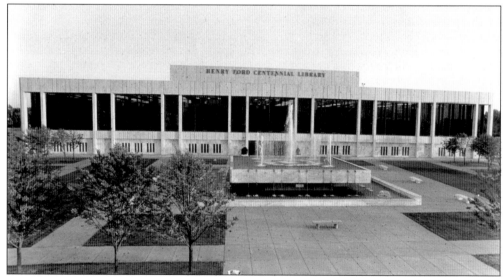

The Henry Ford Centennial Library is pictured here in 1981. The building opened in 1969 on land given by Henry Ford II, then chairman of the Ford Motor Company Board. Two varieties of white marble were used on the exterior, and teakwood panels and doors were used for the interior. The fountain in front is made of white Vermont marble and sprays lighted water 33 feet in the air. In June of 1975, a statue of Henry Ford was unveiled on the side of the library structure. It is the only life-sized statue of Henry Ford in the United States. (Photograph courtesy Dearborn Historical Museum.)

Five

EDUCATING
THE CITIZENS

Dearborn has long been known for the quality education provided by its schools. Schools have been and still are well-funded and the vast majority of graduates from Dearborn schools continue on to higher education. This public education legacy began with the one-room schoolhouses that were built in the Dearborn area. These early one-room schoolhouses were usually attended by a wide age range, from 5 to 18 years of age. Subjects that were taught included Language, Writing, Reading, Grammar, Arithmetic, Geography, History, and Civil Government. Another important goal of early education was moral training. Popular textbooks in the pioneer days were the McGuffey Readers, which not only taught reading, writing, and arithmetic, but also helped to instill moral and ethical principles about things like hard work, lying, cheating, and stealing. The normal school year, due to the agrarian nature of the community, by which everyone was needed to help on the farm, was comprised of one month in the fall, three months in the winter, and two months in the spring.

One of the first schools built in the area was known as the Scotch Settlement School because it was located in a section where mostly Scotch-Irish settlers had established farms. The original building, built in 1838 on a corner of the Richard Gardner farm, was a one-story frame structure with benches and desks along the outside walls of the room. The building was destroyed in a fire and a new brick school was built in 1860 on the north side of what is today Warren Avenue near Southfield Road. Henry Ford started school in this schoolhouse in 1871 at the age of 7. The structure, moved by Mr. Ford in 1929, was part of the Greenfield Village School System until 1969, and now stands to teach people about how a one-room schoolhouse operated. Another early school was the Little Red Schoolhouse (Wallaceville School). First constructed in 1824 as a church, the original log building became a public school in 1829. After John B. Wallace donated the land and building to the school district, the school was named after him. The log structure burned in 1867 and was replaced by a brick schoolhouse. The structure still stands today on North Gulley and is used as a museum. The Miller School, another school built during the pioneer days, was built in 1830 at what is today Michigan Avenue and Miller Road. The building was torn down around the turn of the 20th century. A replica of the structure stands in Greenfield Village.

Most of the public schools presently standing in Dearborn were built in the first half of the 20th century, and although some have closed or been changed from the use for which they were originally intended, many of these stable structures still serve an educational system that is ranked, for quality, in the top 10 in Michigan. The following text and images provide some

background information on many of the school structures. The information and images will be of interest to those who may have attended one of these schools, lived by one of them, or just found themselves curious about a particular school. (For information on the naming of schools, please refer to Chapter Three.)

As Ford Motor Company grew and men came to Dearborn looking for jobs with their families, new neighborhoods sprung up and increased the need for school buildings. Garrison School (today, Salisbury) was in need of relief from overcrowded classrooms. In 1921, Southwestern School was built at the corner of Beech and Francis Streets. Originally, the school taught grades kindergarten through sixth, but after Edison School was built in 1931, the grades offered were reduced to kindergarten through fourth. In 1958, the building was remodeled and a gymnasium, two new classrooms, and a library were added. With the renovation, the school was renamed Duvall.

The Thayer School was built in 1924 to replace the one-room McDonald School at Warren and Wyoming. When it was finished, it was considered one of the most modern school buildings in existence at that time. Representatives from other school districts came to visit and study the design of the building. The school had 8 classrooms, a cafeteria, library, and a gymnasium-auditorium. After just a couple of years, the school was so overcrowded that the locker rooms had to be used as classrooms. This problem was solved by building Lowrey Junior High in 1927. In 1961, the property and building were sold to the Pius Society of St. Paul.

The area east of Monroe and south of Outer Drive grew tremendously in the early 1900s and again there was a need for a school. A Dearborn architect, Harry Vicary, was chosen to assist the firm of George D. Mason and Company with the design of Whitemore-Bolles School. The school opened in 1927 with 4 teachers and 98 students. During the depression, the school was used as a soup kitchen. With a new wave of enrollment after World War II, a new wing was added with additional classrooms and a kitchen. The enrollment had reached 1400 students by 1951. A unique science program called the Horticultural Gardens was established at Whitmore-Bolles in the 1950s.

The first school built in the Springwells School District was the William Ford School. It was constructed in 1922 at Chase Road and Ford Road on what was part of William Ford's (Henry Ford's father) original farm. The land was purchased from Henry Ford for $1. Originally, the school had 6 classrooms, but was expanded in 1924 to 31 classrooms with a gymnasium and auditorium. By 1928, enrollment had grown to 1030 students. When St. Clements School closed in 1971, all of the elementary students were sent to William Ford. Today, the school still holds classes for grades kindergarten through sixth grade.

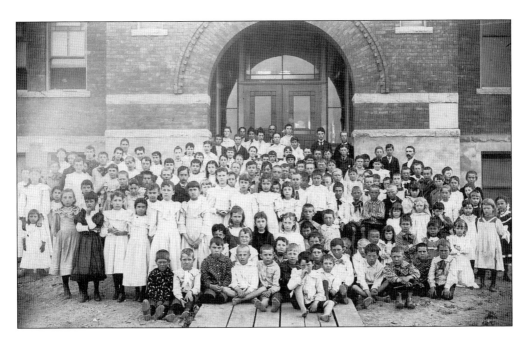

This picture features the class of 1895 at what was known as the Dearborn Public School. Bricks from the arsenal were incorporated into the structure when it was built in 1893 on part of the old arsenal grounds. This structure was also used for high school classes until 1925, when a larger building, known as Dearborn High School, was built on Mason Street. That school is the present day Ray H. Adams Junior High School. (Photograph courtesy Dearborn Historical Museum.)

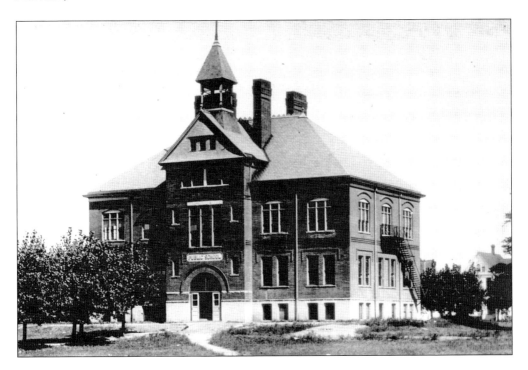

The present-day Salina School is an expansion of the Springwells District #2 School, called the "Rouge School." The first building was a four-room school at Miller Road and Dix, which was purchased by Henry Ford sometime before 1917. The Rouge Plant brought an increase in enrollment and a new structure, located on Salina Street, was completed in 1922. In September 1927, there was an enrollment of 904 students in grades kindergarten through twelfth grade. Today, the school serves as an elementary and junior high school. (Photograph courtesy Dearborn Historical Museum.)

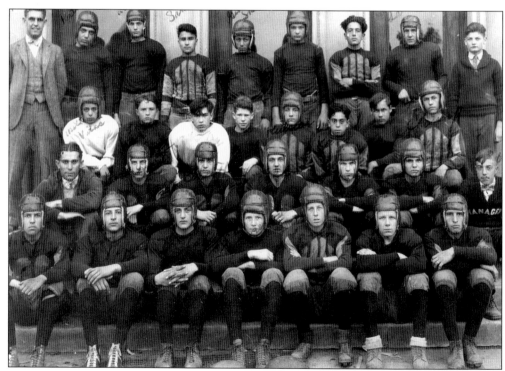

The 1927 Salina High School football team poses for a team picture. This is the last year Salina had a high school, because the next year Fordson High School opened and students were sent there. (Photograph courtesy Dearborn Historical Museum.)

The original Scotch Settlement School, one of the first schools in the Dearborn area, was built in 1838 on a corner of the Richard Gardner farm. Pictured are schoolmates of the Scotch Settlement School (brick structure built in 1860), taken around 1923 at the original site on Warren Avenue in Greenfield Township. Standing in the doorway, seventh from the left, is Grandmother Susie (Stevenson) Coon; third from right is Great Uncle Samuel Stevenson; sitting on the porch at the left are cousins Howard and Susan Proctor; and standing at the far left are Clara and Henry Ford. The school was moved to Greenfield Village in 1929 by Henry Ford. A key to the school's front door was given to each schoolmate at the reunion by Henry Ford. Clara and Henry Ford's initials were on the back of it. (Photograph courtesy Dearborn Historical Museum.)

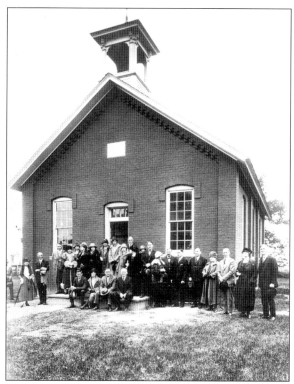

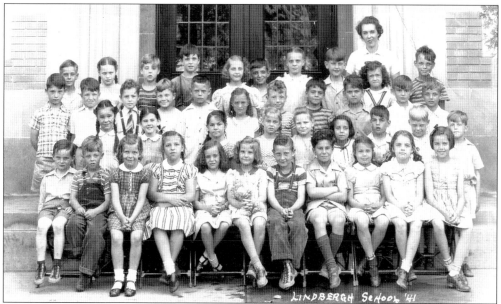

A Lindbergh School class poses for a picture in 1941. An eight-room school building was originally built on the southeast corner of Telegraph Road and Cherry Hill to handle elementary and junior high students. The school was named in honor of famous aviator Charles A. Lindbergh and at the dedication in 1928, his mother was present as a guest of honor. Additions have been made through the years, and the school continues to educate area students today. (Photograph courtesy Dearborn Historical Museum.)

Students at Edison School in 1957. The school opened in 1931 and was formally dedicated on February 11, 1932, the 85th anniversary of Thomas Edison's birth. Mrs. Edison and their son, Charles, attended the ceremony as special guests. In 1952, after a number of new amenities and classrooms were added, the school became a junior high school. By 1978, both the elementary and junior high portions of the school were closed. (Photograph courtesy Dearborn Historical Museum.)

Pictured below is Salisbury School, formerly Garrison School. (Photograph courtesy Dearborn Historical Museum.)

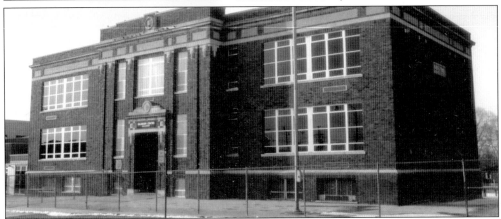

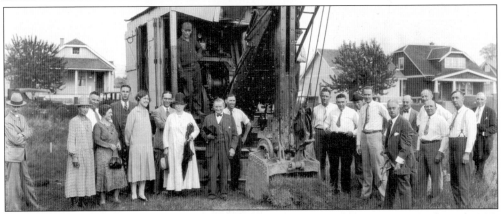

This picture was taken at the ground-breaking for Woodworth School in September of 1927. Present at the ceremony, from left to right, are the following: unidentified man, Mary Selinske, unidentified man, Ida Woodworth, C. Roscoe Simmons, Joe Karman's wife, Fred Oempke, Eleanor Woodworth, Alfred Woodworth Jr., next five unidentified, Alfred Woodworth Sr., next two unidentified, Harvey H. Lowrey, unidentified man, Mr. Imes, and Joe Karman. (Photograph courtesy Dearborn Historical Museum.)

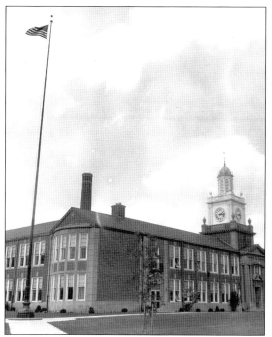

Top left: The property on which Woodworth School stands was originally a portion of the Woodworth farm. Alfred Woodworth came to the Dearborn area with his family when he was 14 and settled in what was then Greenfield Township. The Woodworths built a log cabin on the site of the present day school building. In 1932, the school added its junior high section and is still in the business of educating students today on Ternes Street. (Photograph courtesy Dearborn Historical Museum.)

Top right: Pictured are the only three Woodworth School principals that had ever served in that capacity as of June 1978. From left to right are Otto J. Rowen, 1928–59; Edward Kotharezyk; and H.G. Odgers, 1959–71. (Photograph courtesy Dearborn Historical Museum.)

Edison School, as it appeared in 1977, just a year before it closed. (Photograph courtesy Dearborn Historical Museum.)

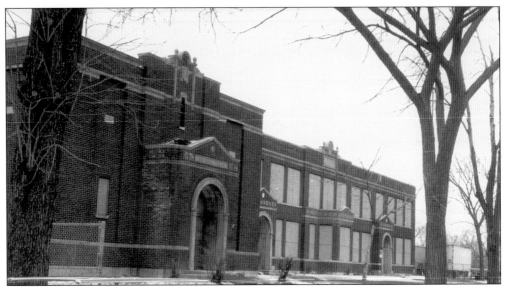

Peter Roulo gave one lot to the City of Detroit in 1906 for a new school to be built in the Springwells Township area. The lot was on the border of Detroit and Springwells. In 1920, the Roulo School became part of the newly established Springwells Township Schools. As the community grew and the need arose, the original building was renovated in 1926. In 1961, the school was closed and the building was leased to the Ambassador Baptist Church. After some fire damage and years of vacancy, the building was torn down in 1979. (Photograph courtesy Dearborn Historical Museum.)

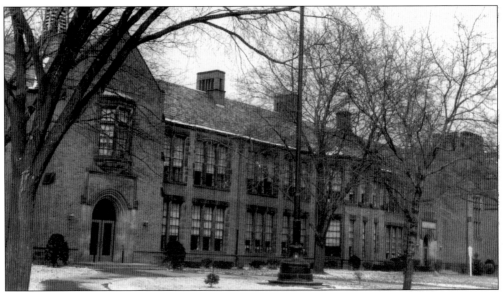

Lowrey School was completed in 1927. Its original purpose was to relieve overcrowding at Thayer and Miller Schools. With the Ford Motor Company's Rouge Plant bringing more families into the area, there was a need for a new school building. The architect that designed Fordson High School, H.J. Keough, designed Lowrey School with a Gothic Collegiate style. In 1949, additions were made that accommodated kindergarten through twelfth grades. Today, it is used for only kindergarten through ninth grade. (Photograph courtesy Dearborn Historical Museum.)

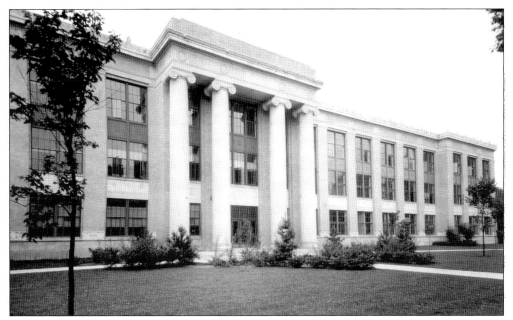

Built in 1926, this building was originally Dearborn High School. With the opening of present day Dearborn High School in 1957, this building became Ray H. Adams Junior High School. Today, the building serves as an office complex. (Photograph courtesy Dearborn Historical Museum.)

Pictured here is Dearborn High School at its present location on Outer Drive just north of Michigan Avenue. After two previous locations, this structure was built at this location in 1957. (Photograph courtesy Dearborn Historical Museum.)

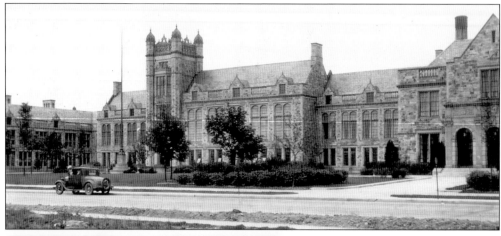

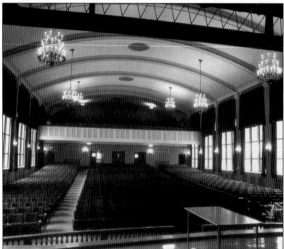

Fordson High School, located on Ford Road between Neckel and Maple, was built in 1926–27 at a cost of just under $2 million. It is the oldest high school building in Dearborn and was named for Henry Ford and his son, Edsel. The architecture is English 16th century Renaissance style. The school's nickname comes from the Fordson tractors that Henry Ford manufactured at his tractor plant and experimented with not far from the school building. The Fordson auditorium, shown below, is one of the finest in any high school in the United States. (Photograph courtesy Dearborn Historical Museum.)

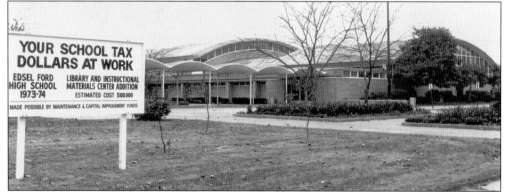

Edsel Ford High School is located on a 40-acre site at Rotunda and Pelham. The land was donated by the Ford Motor Company with the understanding that the school would bear the name of Edsel Ford in honor of his many contributions to education through the Ford Foundation. Completed in 1956, the school, from the beginning, placed emphasis on the Humanities and college preparatory classes. Many programs have been pioneered at Edsel Ford that are now standard curricula in high schools across America. (Photograph courtesy Dearborn Historical Museum.)

Six

LEADERSHIP

BUSINESS AND GOVERNMENT

Any entity created by man will not advance very far without leadership. Leadership will be defined here as vision, the willingness to take a chance, and the fortitude to stick with a course and to see it through if it is something of value. Dearborn has been fortunate to have had a number of leaders of this kind. From its mayors, city council, and business heads, the area has moved forward, in part, because these leaders had a talent to help the city grow into a place that residents could enjoy and be proud of.

In the political realm, the first mayor of the incorporated and consolidated city of Dearborn was Clyde M. Ford (served 1929–36), a cousin of Henry Ford, the auto pioneer. Clyde Ford also ran a Ford dealership in Dearborn with his father, Addison Ford. When his father passed away in 1920, Clyde became the sole owner of a dealership that sold Fords, Lincolns, and tractors. Business boomed during the 1920s and at one time he had 35 employees working at his dealership. Unfortunately, the Great Depression had a detrimental affect on his political and business career. However, he did continue to serve his community, and Clyde Ford was able to hold various positions in Dearborn city government for nearly 30 years.

John L. Carey served as Dearborn's mayor from 1936 until 1942. During his tenure, business picked up again with the onset of World War II. Demand for armed forces supplies caused a vast expansion of the Rouge Plant and the Ford Willow Run Bomber Plant, where B-24 bombers were manufactured. Many Dearborn citizens flocked into the plants to help the war effort. New plants and machine shops were built that helped the war effort in many different endeavors. The City of Dearborn was booming and working at an unprecedented level.

The next mayor, Orville L. Hubbard, served the city for 36 years, the longest term of any mayor in the history of the United States. Under his tenure, Dearborn became known for high-quality and timely city services. Also, the number of parks, playgrounds, and recreational facilities built during his tenure rivaled cities much larger than Dearborn. A gem of the recreational facilities was and still is Camp Dearborn, located in Milford, Michigan. The idea was a novel one: to have a municipal park outside of the city's boundaries. Mayor Hubbard had long dreamed of a camping area for Dearborn citizens and in 1947, that dream was realized. The camp includes 6 lakes, and the 626 acres provide a perfect setting for cross-country skiing, sleigh rides, camping, hiking, swimming, boating, fishing, and golf. Thousands of residents have enjoyed the beautiful surroundings and recreational activities through the years.

John B. O'Reilly became mayor in 1978 and the city continued to grow and prosper. The present mayor, Michael A. Guido, served on the city council before being elected mayor in

1986. He was 32 years old when he took the oath of office, the youngest mayor in Dearborn history. His tenure has been marked by enormous developmental growth for the city and a tremendous increase in property values. One of the major dreams that has come true during Mayor Guido's service was the building of a first-class center for the citizens of Dearborn, the Ford Community & Performing Arts Center.

As anyone who lives in a capitalist society knows, business opportunities and eager entrepreneurs willing to take advantage of them are tremendously important to an area, providing jobs and services to the community. Titus Dort, who settled in Dearbornville in 1829, was one of the first individuals to start a brick-making business. This kind of business was possible due to the large clay deposits in the area. Dort's company was instrumental in erecting the first brick buildings in the area, including the arsenal buildings. Conrad Clippert was another business leader who engaged in brick-making. The Clippert Brick Company was established in 1870 and operated until 1973 on the corner of Wyoming and Southern. This industry is Dearborn's oldest.

A gristmill was one of the most important businesses to exist in a farming settlement and in the Dearborn area, one of the first gristmills was operated by Joseph Coon. Anthony Wagner and his son Charles erected the Wagner Hotel on the southwest corner of Michigan and Monroe. The building still stands today. In terms of the service industry, one of the first doctors in the area was Dr. Edward S. Snow. He graduated from medical school in 1847. He served as physician and surgeon at the Detroit Arsenal in Dearbornville until it closed in 1875. He also served as surgeon for the Michigan Central Railroad for 43 years. The world's first airport hotel was built in Dearborn by Henry Ford in 1931 to accommodate overnight travelers arriving at the Ford Airport. A unique feature of the Dearborn Inn's accommodations include replicas of historically famous homes: the Patrick Henry House, the Oliver Wolcott House, the Edgar Allen Poe House, and the Walt Whitman House. The first car dealership in Dearborn was run by Addison Ford, a cousin of Henry Ford. In 1911, he sold 11 cars and had to teach most of the buyers how to drive their automobiles. Of course, no list of businesses and business leaders in Dearborn, or for that matter, the world, would be complete without a discussion of Henry Ford. This industrial leader would change the face of Dearborn forever and make the city known around the world with his Ford Motor Company and River Rouge Plant.

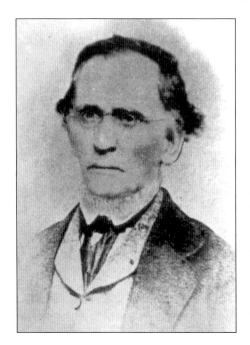

Brick-making was the first industry in Dearborn. Titus Dort (1806–1879), moved to the rural town of Dearbornville in 1829 and began brick-making on the Rouge River. In 1833, he entered into an agreement to manufacture bricks for a series of 11 buildings that were to make up the U.S. Arsenal. Dort continued to make bricks until 1851 and served in many local political capacities as well. (Photograph courtesy Dearborn Historical Museum.)

Conrad Clippert established the Clippert Brick Company in 1870. A pioneer of German descent, he also served as Wayne County Sheriff. (Photograph courtesy Dearborn Historical Museum.)

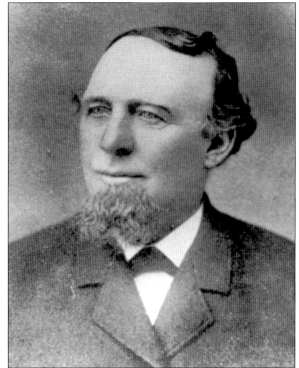

Conrad Clippert is pictured here wearing white sleeves and a straw hat. His brick company was established in 1870 and operated until 1973 on the corner of Wyoming and Southern. (Photograph courtesy Dearborn Historical Museum.)

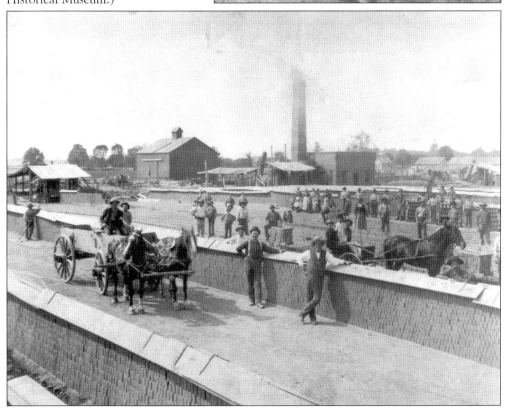

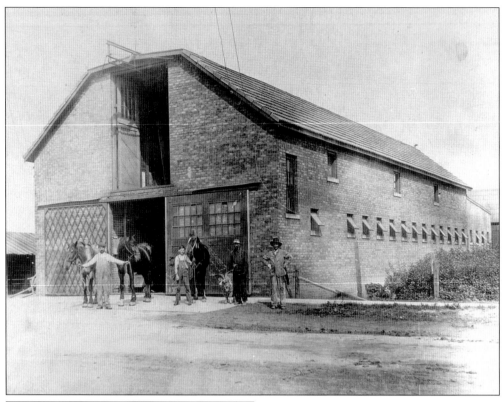

The Clippert Brick Company owned a barn for their horses on the grounds of the company. William Seubert and his son Mike cared for the horses. This photograph dates to c. 1913. (Photograph courtesy Dearborn Historical Museum.)

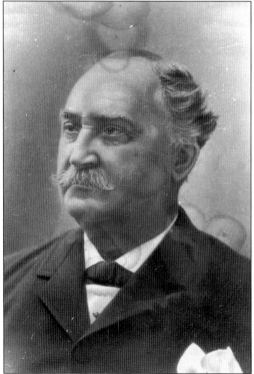

Joseph Coon (1814–1889), sometime before 1850, erected a gristmill on Outer Drive between Ford and Warren Avenue and 1.5 blocks from Ann Arbor Trail. The grist mill played a pivotal role in the frontier area as it provided meal and flour as a product of the settler's harvest. (Photograph courtesy Dearborn Historical Museum.)

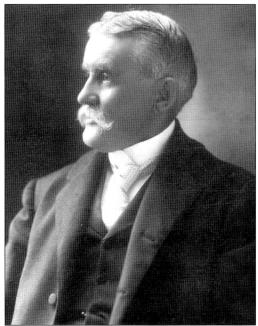

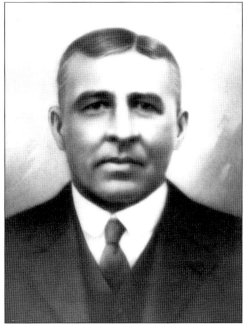

Top left: Elba Howe, pictured here in 1890, came to Dearborn in 1861 from New York State as an agent of the Michigan Central Railroad. Looking for additional income to "make ends meet," he started a flour and feed store. Then in 1875, Howe founded the first undertaking establishment in the small village of Dearbornville. (Photograph courtesy Dearborn Historical Museum.)

Top right: Addison Ford (1864–1920), a cousin of Henry Ford, grew up on a farm near Joy and Greenfield Roads. He took over the family farm in 1901, but much like his cousin, he had an attraction to mechanical things. In 1910, he was granted a license for a Ford dealership, the first one in Dearborn. His only son, Clyde, took over the business when Addison passed away and he was elected Dearborn's first mayor after the consolidation in 1928. (Photograph courtesy Dearborn Historical Museum.)

Bottom right: Floyd E. Yinger served on the Fordson Board of Education from 1924–28 and was the Mayor of Fordson (East Dearborn) in 1928 when citizens of Fordson and Dearborn voted to consolidate. Yinger was elected chairman of a nine-member commission to help with the consolidation. He ran for mayor of the new consolidated Dearborn against Clyde Ford and James Casey. Clyde Ford won the election. (Photograph courtesy Dearborn Historical Museum.)

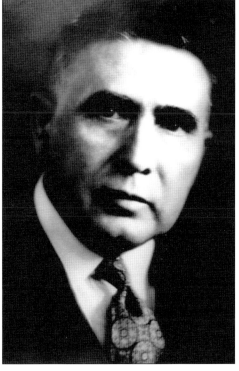

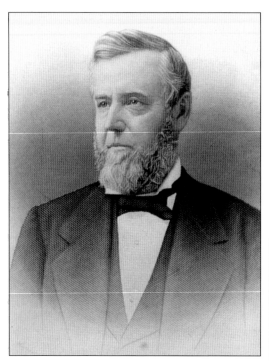

Dr. Edward Snow (1820–92) was one of the first doctors in Dearborn. An experience taking care of an ill friend at a young age led him to study medicine. In 1847, he graduated from the medical department at Western Reserve College in Cleveland, Ohio. When he came to Dearborn, he served as physician and surgeon at the arsenal in Dearbornville until it closed in 1875. He served as surgeon for the Michigan Central Railroad for 43 years. He also served as school inspector for Dearborn Township. (Photograph courtesy Dearborn Historical Museum.)

Pictured to the right is Joseph M. Ford, in 1946, when he served on the Dearborn City Council. (Photograph courtesy Dearborn Historical Museum.)

Clyde M. Ford (1887–1948), son of Addison Ford, became a great car and tractor salesman in his father's Ford dealership and became the sole owner of the business in 1920. He became involved in politics when he moved his family into the Village of Dearborn in 1927. He was elected mayor of the City of Dearborn both before and after the consolidation with Fordson. He served in other civic capacities in his career such as city controller and assessor. (Photograph courtesy Dearborn Historical Museum.)

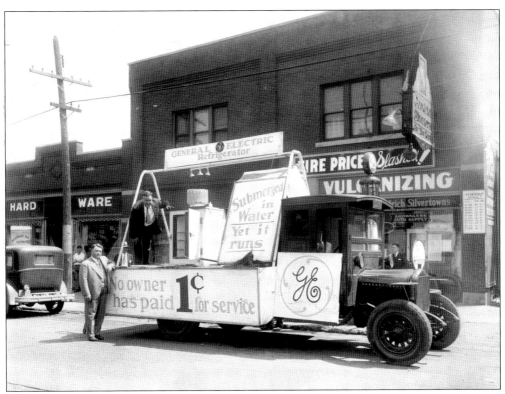

The man standing next to the truck is Clyde Ford. The location is Michigan Avenue and Oakwood in the late 1920s or early 1930s. (Photograph courtesy Dearborn Historical Museum.)

Michael Adray is a well-known name in Dearborn. His Adray Appliance store has operated for many years up to the present time on Carlysle Street. His support of the community included funding for many different recreational activities, including baseball and an ice arena that bears his name. This picture shows him (right) shaking hands with Mayor Hubbard in 1967. (Photograph courtesy Dearborn Historical Museum.)

John Carey (right) won the race for mayor of Dearborn in November of 1935. He served from 1936–42. Here he is seen throwing out the first pitch of a baseball game at St. Joseph's Retreat field at the northeast corner of Michigan Avenue and Outer Drive. Notice St. Joseph's Retreat in the background. (Photograph courtesy Dearborn Historical Museum.)

Mayor John Carey was the second mayor to preside over the consolidated City of Dearborn. He won the election of 1935 over Orville Hubbard. During his tenure, World War II caused an upswing in Dearborn's economy due to the need for the Rouge Plant and other industrial plants to manufacture materials of war. (Photograph courtesy Dearborn Historical Museum.)

In November of 1941, Orville L. Hubbard defeated Clarence Doyle to become mayor of Dearborn. By the end of his career, he had served 15 consecutive terms, the longest of any mayor in the history of the United States. During Hubbard's time in office, Dearborn was known for its city services and safe, clean environment in which to raise a family. Although controversial for some of his social philosophies, his popularity with the people of Dearborn remained high. (Photograph courtesy Dearborn Historical Museum.)

After serving Dearborn as chief of police, John B. O'Reilly became the Mayor in 1978 and served until 1986. Under Mayor O'Reilly, the city continued to grow and prosper and was transformed into a very modern city. At the same time, the city stayed rooted to the traditions of home, family, and history. His son, John B. O'Reilly Jr., is presently serving the community as president of the Dearborn City Council. (Photograph courtesy Dearborn Historical Museum.)

In 1955, actor Thomas Mitchell (below) visited Dearborn and met with Mayor Hubbard. Mitchell played mayor of the town on television. Mayor Hubbard's career as mayor was also marked by growth in the industrial, residential, and retail areas of the city as well as exceptional recreational programs. (Photograph courtesy Dearborn Historical Museum.)

Mayor O'Reilly took the opportunity to demonstrate his musical skills by conducting the Dearborn Symphony Orchestra at the 1980 Homecoming celebration. (Photograph courtesy Dearborn Historical Museum.)

Michael A. Guido, at the age of 23, became the youngest person ever elected to the Dearborn City Council. He served two terms in that capacity until being elected mayor of his hometown in 1986. He is a lifelong resident and a product of the Dearborn Public Schools. Guido has continued the city's tradition of excellent city services and recreational facilities while also looking for ways to help the city continue to grow. Numerous building programs have been completed during his tenure including Dearborn's Ford Community and Performing Arts Center, the largest municipally-owned community recreation and cultural complex in North America. (Photograph courtesy Dearborn Historical Museum.)

Seven

Dearborn's Most Famous Son

Henry Ford

Henry Ford was born into a world of change on July 30, 1863. He grew up on a farm (noted by a historical marker at the location at Ford and Greenfield Roads) in Greenfield Township, which is known today as the City of Dearborn. He helped his parents with the chores that were typical of the time period. His father, William, owned and operated a very successful farm where hay was the main cash crop. Henry went to school off and on for six years at the Scotch Settlement and Miller Schools. He lived a typical farm life for a boy in the 19th century. However, the hard, monotonous work that a farmer had to perform was something that did not interest Henry. He was interested in engines and mechanical things even in his early childhood. In 1879, Henry left the farm and walked nine miles to Detroit, which had a number of machine shops, to pursue his mechanical interests.

After a few years honing his skills in machine shops, repairing steam engines for Westinghouse Road Engines, and rising to chief engineer of the Detroit Edison Illuminating Company, the dream of an internal combustion engine loomed large. After building a successful engine and driving his first car, the Quadricycle, he set out to produce automobiles for the public. Henry believed that the automobile was a tool, not a luxury, and should be available to the masses. He introduced the legendary Model T, the car that "put America on wheels," in 1908 and instituted the moving assembly line in 1912 at the Highland Park plant. His production techniques made it possible to keep lowering the price of each vehicle. In 1913, as their lives in Detroit became more hectic, Henry and his wife, Clara, decided to return to the area of their childhood. The Fords built an estate, Fair Lane, on the Rouge River that served as a home, laboratory, and a place to enjoy nature. Henry had a separate structure built that served as a powerhouse, which made the house self-sufficient. The automaker shocked the world in 1914 with a profit sharing plan that paid his workers $5 a day, nearly doubling their previous wages. He also reduced his employees' work day from 10 to 8 hours. This not only allowed his workers to afford a car themselves, but reduced the worker turnover rate.

Not far from his estate, Henry began the development of a 2,000-acre area along the Rouge River. The first items produced at the River Rouge Plant were Eagle boats, intended for use during World War I. In 1921, tractors were turned out at the plant as Ford had long wished to free farmers from much of the hard toil of their work. After this initial production, the Rouge Plant was eventually expanded into the world's largest industrial complex by the late 1920s. The design of the complex was the fulfillment of the ultimate in mass production. Raw materials could be transformed into finished products within a matter of hours. By the 1930s,

iron ore would enter one end of the plant, was melted, molded, and converted into a finished automobile in only 28 hours. Thousands flooded to Dearborn for the opportunity to work at the Rouge Plant, and at its peak employment in 1929, the Rouge complex had 103,000 workers. Michigan Avenue (the old Chicago Road) was paved seven lanes wide to accommodate traffic moving back and forth from the Rouge Plant. During World War II, the Rouge Plant was expanded and produced jeeps, military trucks, tanks and tank destroyers, amphibious vehicles, armored cars, universal carriers, and aircraft engines for the war effort. The headquarters of the Ford Motor Company was originally built on Schaefer Road not far from the Rouge Complex, but as the company grew, a large structure known as the "glasshouse" was completed in 1956 on Michigan Avenue. The Dearborn area was no longer just a quiet countryside and farming community.

Ford created other enterprises in Dearborn. In 1919, he entered the housing business with the creation of what is known today as the Ford Homes Historic District. The homes were built to solve the housing problem that Ford's tractor plant workers were having. One of the unique aspects of the Ford Homes is that they were built by production line techniques with a separate crew doing only one task per house. This technique is still in use today. The Dearborn Inn, built in 1931, was the world's first airport hotel. Ford was a pioneer in promoting safe, affordable air travel. Ford Tri-Motor airplanes were assembled at a building at Ford Flying Field right across the road from the Dearborn Inn. Numerous firsts occurred at the Ford Airport: the first airline terminal operated from 1924 to 1933; the first regularly scheduled airline service started in 1925; and the first air mail service in 1926; and a guided flight of a commercial airliner was made there by radio in 1927. Many of the first major airlines started out with Ford Tri-Motors.

Another interest of Henry Ford's was collecting Americana and preserving a past that he, as much as anyone, had helped change. In 1919, he restored his birthplace and soon had filled an entire wing of his engineering building in Dearborn with artifacts. The Edison Institute, which today comprises the Henry Ford Museum and Greenfield Village, was dedicated on October 21, 1929. He started the complex as a school where students could learn by his philosophy of "learning by doing." Known to the residents of Dearborn as simply "the village," the complex was a dedication to Ford's mentor and friend, Thomas A. Edison. The 240-acre village is a collection of over 100 historic structures that help tell the story of a slow-paced, rural countryside and the impact that the industrial revolution and the inventions of men like Thomas Edison had on the lives of mankind. The Henry Ford Museum, the entrance of which is a replica of Independence Hall in Philadelphia and 12 acres in size, houses numerous artifacts that help tell the story of transportation, farming, industrialization, and life in America's past.

While much more could be written about Henry Ford and his interests and contributions, one thing is certain, he put the City of Dearborn on the world map. The company he started a century ago is a global entity and Dearborn is a famous industrial center because of it. The Greenfield Village Schools he established lasted until 1969, but today, the historical complex that he began is annually visited by over one million visitors from all over the world. It is ironic that within the confines of one city, one can learn about an agrarian past that Henry Ford was born into and at the same time see the changes that he himself helped to bring about.

Henry Ford (1863–1947): industrialist, preservationist, educator, social engineer. Numerous labels in addition to these could be used to describe the man who helped put America on wheels. Born on a farm in what is today Dearborn, he lived the typical farm life of the 19th century. Mechanical things fascinated and beckoned him to a different life, however, and in the end, he contributed to and influenced life in Dearborn and all over the world in ways most would never have imagined. (Photograph courtesy Dearborn Historical Museum.)

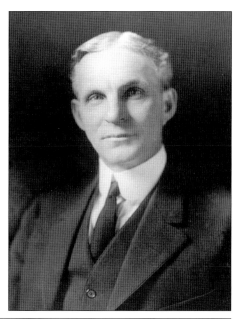

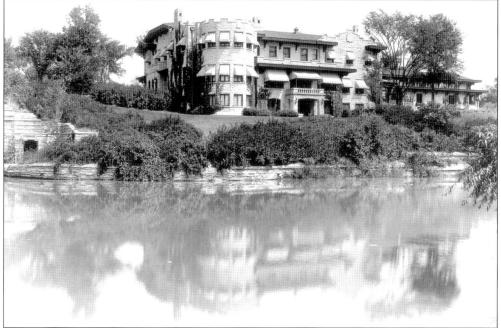

The success of the Ford Motor Company brought a stream of uninvited guests to Henry and his wife Clara's mansion in the Boston Edison District of Detroit. They wanted to build where they could have their privacy and enjoy some of their interests like nature, gardening, and bird-watching. The location they chose was approximately two miles from the farm where Ford was born. Over 500 masons, woodcarvers, and artisans worked on the residence, which was built with rough-hewn Ohio limestone. Completed in 1916, the home, known as the Henry Ford Estate, or Fair Lane (Henry referred to it as "the residence"), had its own powerhouse in order to make it self-sufficient. It served as their home until their deaths in 1947 (Henry) and 1951 (Clara). (Photograph courtesy Dearborn Historical Museum.)

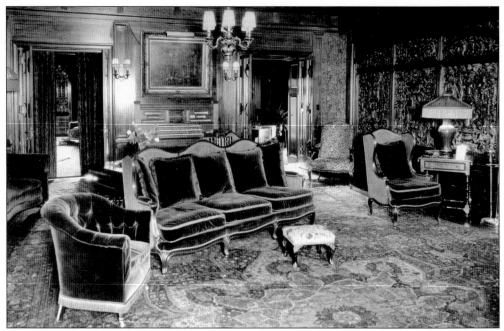

The parlor of Henry and Clara's Estate, pictured here in 1926, was just one of 56 rooms in the mansion. The home was built with such amenities as a heated pool, bowling alley, and library where Henry liked to sit and have Clara read to him. (Photograph courtesy Dearborn Historical Museum.)

A great lover of roses, Clara Ford had an immense rose garden (over 10,000 plants), as can be seen from this picture taken in 1927. Much of the grounds of the estate was designed by noted landscape architect, Jens Jenson. Utilizing his unique eye, the grounds were transformed from farmland into a natural, native landscape. (Photograph courtesy Dearborn Historical Museum.)

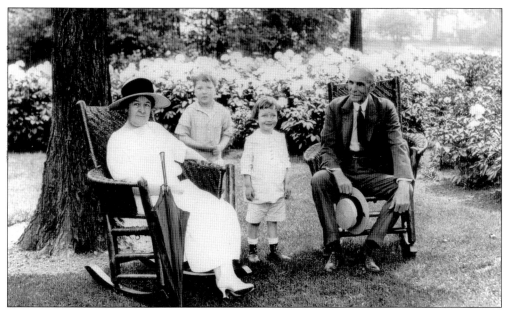

From left to right are Clara Ford, Henry II, Benson, and Henry in the garden at Fair Lane in 1923. The grandchildren would come over quite often and play on the grounds of the estate. (Photograph courtesy Dearborn Historical Museum.)

On the grounds of Fair Lane in 1918, Henry Ford shows his grandsons Henry II and Benson how to dig potatoes. (Photograph courtesy Dearborn Historical Museum.)

Henry and Clara's grandsons visited Fair Lane quite often. Here, Henry Ford II (in sleigh) and Benson Ford try to get things moving in 1922. These two had some remarkable times in the countryside of Dearborn with their grandparents. (Photograph courtesy Dearborn Historical Museum.)

Enjoying a relaxing moment, Henry Ford and his grandson, Henry Ford II, sit perched high up in a tree house Ford had built on his estate, Fair Lane. (Photograph courtesy Dearborn Historical Museum.)

Preparing a telescopic bird-watching session on Ford's Dearborn preserve, from left to right are Glenn Buck (Chicago advertising agent and prominent member of the Audubon Society), Henry Ford, and John Burroughs, the naturalist. Buck introduced Burroughs to Ford in June 1913. The 1300 acres of the estate were used by Henry and Clara as a nature preserve. Numerous types of animals and birds were brought to the grounds for the enjoyment of the Fords and their visitors. (Photograph courtesy Dearborn Historical Museum.)

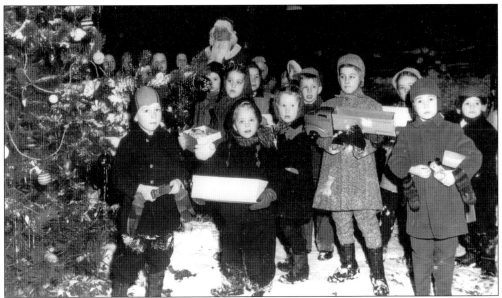

Henry Ford plays Santa at Santa's Workshop for Greenfield Village School children at Fair Lane in December of 1946. If there was snow, children were given a sleigh ride to Santa's Workshop in the woods of Fair Lane. Santa would toss down candy from the rooftop and then appear at the door inviting the children into the cabin for hot soup and presents for all. This experience created many great memories for those children who participated from around the area. (Photograph courtesy Dearborn Historical Museum.)

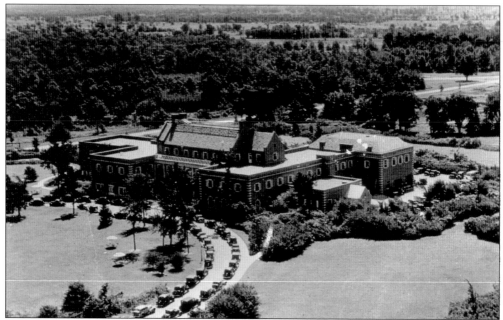

The Dearborn Inn, shown here in 1935, was built by Henry Ford in 1931 and was the world's first airport hotel. The Inn accommodated overnight travelers arriving at the Ford Airport, which was just opposite the hotel on Oakwood Boulevard. The 179-room Inn was designed by famous Detroit architect Albert Kahn. The architecture is Georgian and still features a crystal-chandeliered ballroom. Its rooms are furnished with reproductions of 18th- and 19th-century furniture. Today, the hotel is run by Marriott, Inc. (Photograph courtesy Dearborn Historical Museum.)

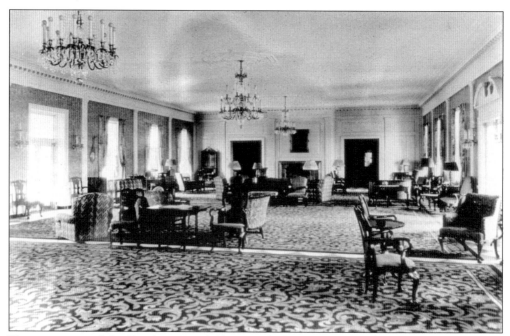

Here is a view of the Dearborn Inn lobby as it looked in 1931, the year the Dearborn Inn opened. (Photograph courtesy Dearborn Historical Museum.)

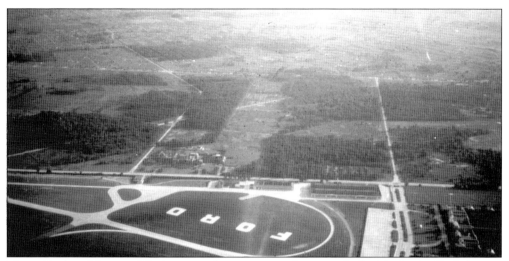

Henry Ford and his son Edsel were early supporters of air travel. Ford built the Ford Airport in 1924 and sought to achieve in aviation some of the things he had with automobiles. There were a number of firsts that came from Ford's work with air travel: airport hotel, guided flight of a commercial airliner by radio, construction of an all-metal airliner, regularly scheduled airline service, and an airline terminal for passenger use. The closing of the airport in 1933 ended Ford's experimental work in aviation. (Photograph courtesy Dearborn Historical Museum.)

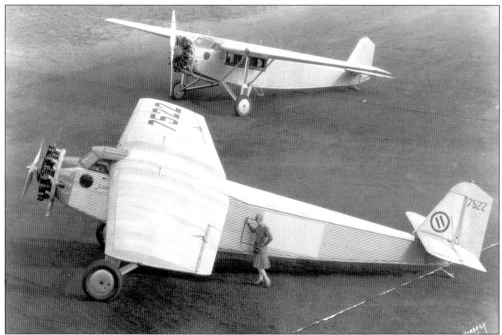

Pictured here are William B. Stout's first all-metal, single-engine planes at the Ford Airport in 1928. Stout worked with Henry Ford in the aviation field and his company, the Stout Metal Airplane Company, became a division of Ford Motor Company in 1925. Stout built the first successful commercial metal planes and was a consulting engineer on the famous Ford Tri-Motor, which were used in the planes of many of the early major airlines. (Photograph courtesy Dearborn Historical Museum.)

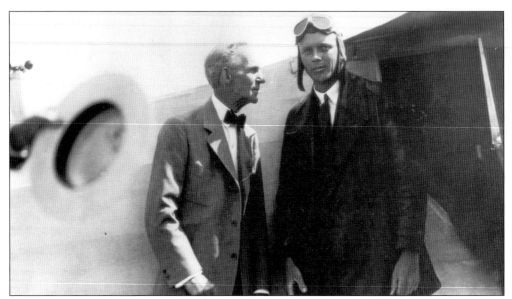

Henry Ford greets Charles Lindbergh at the Ford Airport on August 11, 1927. Ford liked people he thought were "self-starters," folks who had made something of themselves and who influenced those around them with hard work and ingenuity. For Ford, Charles Lindbergh fit into this category. Lindbergh was invited to stay with the Fords at Fair Lane on a number of occasions. During his visit to Ford Field, Lindbergh gave Ford his first plane ride. (Photograph courtesy Dearborn Historical Museum.)

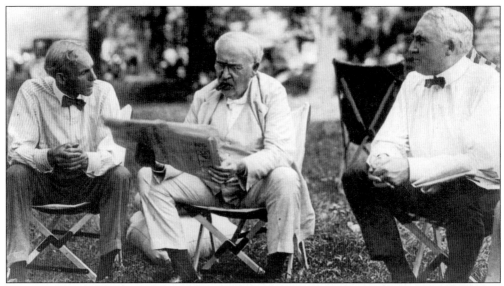

Henry Ford and Thomas Edison had a close relationship later in their lives. Their friendship stemmed from some encouraging words given by the world-famous inventor to Ford when he was developing his first horseless carriage. To Ford, Edison represented the spirit of American ingenuity and greatness. The automaker joined Edison, John Burroughs, and Harvey Firestone on camping trips from 1916 into the 1920s. Once in a while, they would be joined by a United States President. Pictured here, from left to right, are Henry Ford, Thomas Edison, and President Warren G. Harding on one of these trips in the 1920s. (Photograph courtesy Dearborn Historical Museum.)

Edsel and Henry Ford are pictured outside the engineering laboratory building on Oakwood Boulevard c. 1927. Edsel was attracted to the overall design of a car. He introduced the styling division of the Ford Motor Company. He played a major role in the design of the 1928 Model A and in the styling advances of the 1930s. Edsel is also credited with the design that started the Lincoln Continental model. He was influential in the development of the Detroit Institute of Arts and sponsored the Diego Rivera murals of industry that still exist today. He passed away at the age of 49 in 1943 from stomach cancer and undulant fever. (Photograph courtesy Dearborn Historical Museum.)

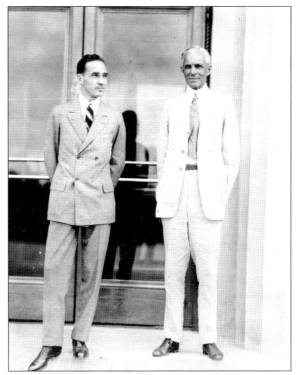

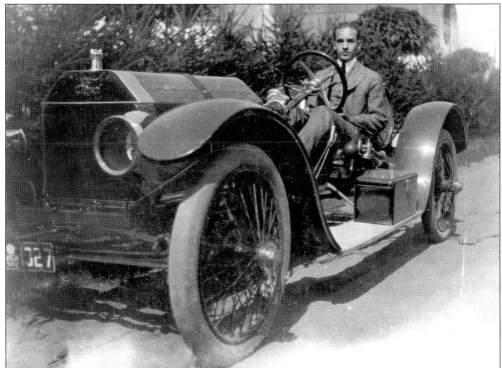

Edsel, Henry Ford's son, is seated in a 1913 Ford automobile. Note: Date taken from license plate. This picture is a rare image. (Photograph courtesy Dearborn Historical Museum.)

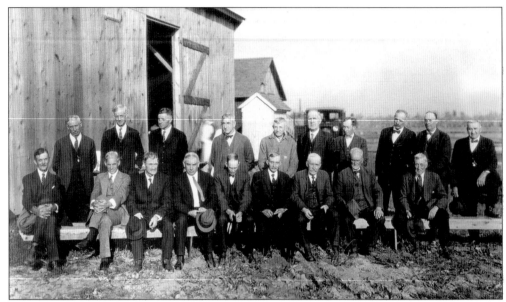

Henry Ford poses here on his 60th birthday with farmer friends at site of Ford's birthplace on Ford and Greenfield Roads, July 30, 1923. Even though he had left the farm and pursued mechanical interests, he never forgot the farmer and his toil. Ford sought ways to take the burden off the back of farmers. One way he did this was by introducing the Fordson Tractor. Through the 1920s, nearly three-quarters of all tractors made in America were Fordsons. (Photograph courtesy Dearborn Historical Museum.)

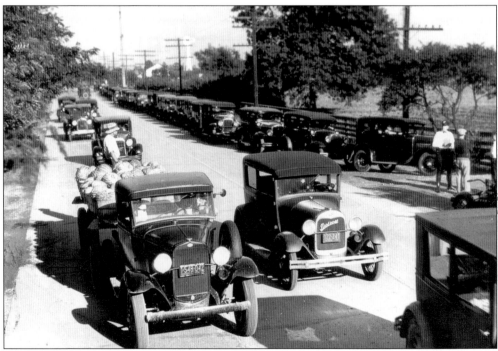

This picture was taken in the summer of 1931 at one of the Ford Farms. The experiment paid off for the farmers. (Photograph courtesy Dearborn Historical Museum.)

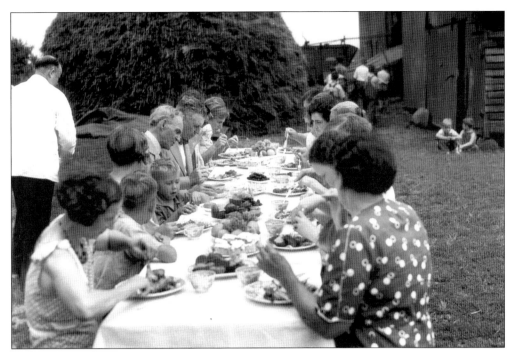

Henry Ford owned thousands of acres in and around Dearborn. During the Depression years of the 1930s, when many people struggled, he let them use his farms and furnished tractors. Plots were cultivated and folks joined together to harvest the crops. Ford then helped them to sell and deliver their product. Everybody made a profit and had enough to eat. Above, Mr. Ford eats dinner at one of his farms. Both pictures are from 1931. (Photograph courtesy Dearborn Historical Museum.)

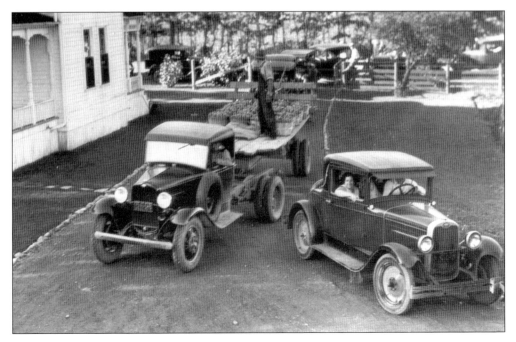

Among the many titles given to him, Henry Ford was also known as the friend of the farmer. In this photo, he talks to area farmers on his 65th birthday at the Fordson Tractor Demonstration on July 30, 1918. (Photograph courtesy Dearborn Historical Museum.)

FORD HOME MODEL "E", by Dorothy Hanna

Albert Wood, an architect on the Ford Motor Company staff, designed
six different models labeled "A" through "F", and Harry C. Vicarey
headed the mechanical work on the construction.

To solve the housing problem that workers at the local Henry Ford & Son Tractor Plant faced, Henry Ford established the Dearborn Realty and Construction Company in 1919. Unique features of the Ford homes included colonial architecture, porches for summer enjoyment, and single, central chimneys. There were six models, and much like Ford cars, they were named by letters; the homes were designated A, B, C, D, E, and F. (Photograph courtesy Dearborn Historical Museum.)

The Ford Homes were built using production line techniques; one crew performed and completed one task, then another came in to attend to the next task, and so on until the structure was finished. This principle is still used in home building today. To purchase one of the homes, a buyer bypassed the banks and worked directly with the Dearborn Realty and Construction Company. The buyer paid monthly payments to Dearborn Realty. Though 350 homes were originally planned, only 156 were built in what is today the Ford Homes Historic District. (Photograph courtesy Dearborn Historical Museum.)

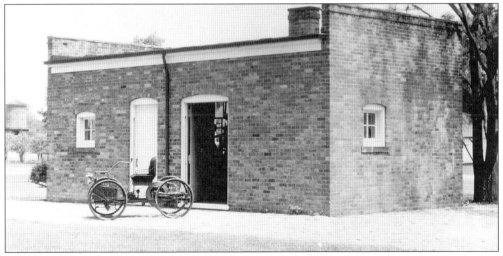

Greenfield Village, the outdoor museum portion of the Edison Institute (Henry Ford Museum and Greenfield Village), was dedicated by Henry Ford in 1929 to preserve how Americans lived and worked from the time of the first settlers through the changes the industrial revolution brought. One of the structures there is the Bagley Avenue Shop, a replica of the red brick shed that originally stood behind the home of Henry Ford in Detroit and was made over into a small machine shop. It was in this building that Ford made his first gasoline-powered car in 1896. Bricks from the original structure were incorporated into the building. (Photograph courtesy Dearborn Historical Museum.)

One of the schools Henry Ford attended in the Dearborn area was the Scotch Settlement School. Pictured is the building after it was moved to Greenfield Village. The original location of the school was on the north side of Warren between Greenfield and Southfield. Pictured here, from left to right are Howard Proctor, Henry Ford, Joe Rycraft, Ruby Proctor, and Susan Proctor. (Photograph courtesy Dearborn Historical Museum.)

This is a view of the Plympton and Susquehanna houses in Greenfield Village. The Plympton House, purchased by Henry Ford and moved in 1933, is the oldest American house in the village, dating back to the 1640s. It is a one-room pilgrim home from Massachusetts. The Susquehanna Plantation house was a stately dwelling of a well-to-do Maryland family who owned slaves. This is the kind of powerful history lesson Henry Ford intended: demonstrating how people worked and lived in different eras and in different areas. (Photograph courtesy Dearborn Historical Museum.)

Grimm Jewelry Store, shown here in 1964, was moved from Michigan Avenue in Detroit in 1940. Henry Ford was personally familiar with this structure as he had worked in Detroit at the Edison Illuminating Company. Ford loved tinkering with pocket watches throughout his life, and he often stopped in the store to chat with Mr. Grimm. The shop is typical of the small specialty shop that prospered in urban areas in the late 1800s. (Photograph courtesy Dearborn Historical Museum.)

This kind of Cape Cod windmill dotted the landscape along the east coast. Strong ocean breezes turned the arms, which then drove millstones for the grinding of grain into flour and meal. Shown here in Greenfield Village in 1953, this Dutch-type windmill was built more than 300 years ago in Cape Cod, Massachusetts, making it one of the oldest in the country. (Photograph courtesy Dearborn Historical Museum.)

Henry Ford became friends with agricultural chemist George Washington Carver. Both men shared an interest in deriving commercial and industrial products from agricultural materials. To honor Dr. Carver, Ford built what he called the George Washington Carver Memorial, a replica of the cabin where he was born into slavery in Diamond Grove, Missouri. His innovative methods of farming led an agricultural revolution in the early 1900s. Pictured here, from left to right, are Edsel Ford, Dr. Carver, and Henry Ford on July 21, 1942. (Photograph courtesy Dearborn Historical Museum.)

This picturesque scene shows a horse-drawn sleigh as it passes the Cotswold Cottage in Greenfield Village. Originally nestled in the Cotswold Hills of England, this picturesque 17th-century limestone cottage suggests the old-world origins of many of the famous and not-so-famous Americans represented in Greenfield Village. (Photograph courtesy Dearborn Historical Museum.)

Henry Ford was able to obtain the original Wright Brothers Cycle shop from Dayton, Ohio, where the brothers developed and built the first flyer to make a successful, manned, powered flight. Orville and Wilbur used this shop as a laboratory. It was dismantled from its original location and transported to Greenfield Village in 1936. (Photograph courtesy Dearborn Historical Museum.)

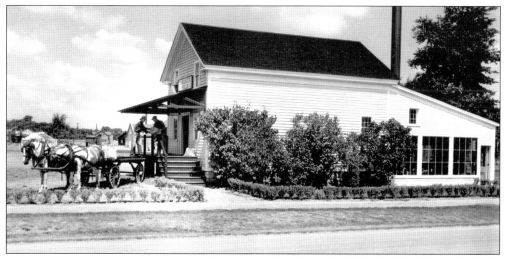

The gristmill was a very important structure to early settlers and farmers. They needed a place to take their harvest crop and have it ground into meal or flour. Henry Ford, in preserving the history of the early settlers on the frontier, had the Loranger Gristmill brought from Monroe, Michigan, to Greenfield Village in 1929. The mill was originally water-powered, and Ford had it converted to steam power in the museum village. For a number of years, it produced flour for area hospitals. This photo dates to c. 1964. (Photograph courtesy Dearborn Historical Museum.)

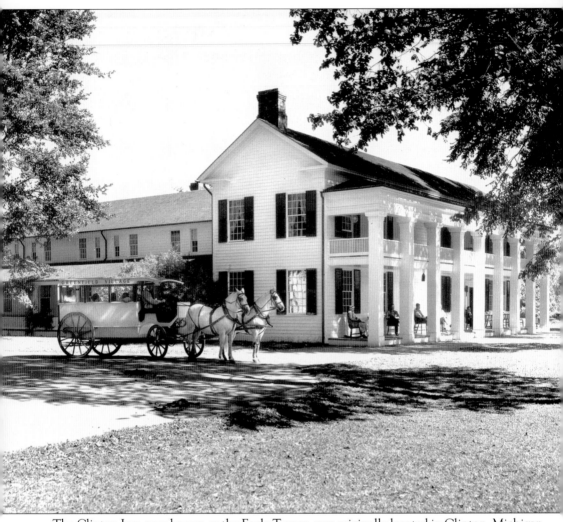

The Clinton Inn, now known as the Eagle Tavern, was originally located in Clinton, Michigan. In the mid-19th century, it was the first overnight stagecoach stop on the Great Sauk Trail from Detroit to Chicago (now U.S. 12, or Michigan Avenue). President James Polk, Daniel Webster, and James Fenmore Cooper were among notable Americans who stopped there at its original location in Clinton. Moved by Henry Ford to Greenfield Village in 1928, it has been restored and furnished to resemble a tavern typical of its time. (Photograph courtesy Dearborn Historical Museum.)

Visitors to Greenfield Village watch how barrels and buckets are made at the Coopershop. The Village and Museum trace the growth of American crafts and industry from the home through small craft shops to 19th-century factory buildings. This coopershop, moved from New Hampshire, was built in 1785. Coopers were important to the growth of shipping because their products (barrels and other wooden articles) were often the only containers available in colonial America. (Photograph courtesy Dearborn Historical Museum.)

The Chapman House was built in 1860 in Dearborn Township (now Dearborn) on Ford Road between Southfield and Greenfield. It stood next to the farm of John Salter, whose pioneer log cabin dates from the 1820s. John Brainard Chapman, who lived in this house, was Henry Ford's favorite teacher at both the Scotch Settlement and Miller schools. The Chapman House was moved to Greenfield Village in 1929 by Henry Ford in honor of his teacher. (Photograph courtesy Dearborn Historical Museum.)

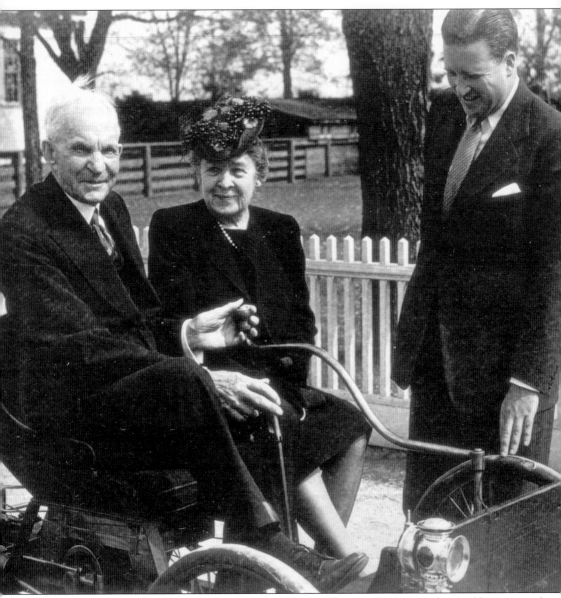

Henry Ford and Clara sit in the quadricycle in front of his own birthplace that had been moved to Greenfield Village from its original location just one year earlier in 1944. The quadricycle was Henry's first horseless carriage. Standing is Henry Ford II, their grandson. (Photograph courtesy Dearborn Historical Museum.)

Eight

SIGNIFICANT EVENTS AND OCCASIONS

Over the years, the area has seen many significant events, interesting happenings, and ceremonial occasions. Entering the year 1928, the cities of Dearborn and Fordson stood as two separate entities. There was a growing movement of people who felt the two should consolidate into one city. Many felt that the merger would bring not only growth and an increase in value to the community, but also lower taxes. There was much debate and concern on both sides of the issue. Respecting his opinion, many wanted to know what Henry Ford thought about the issue. Also, since his home and industrial complex would be affected, he had a personal stake in the outcome. Ford gave his written endorsement of consolidation and in June of 1928, voters approved the merger and on January 9, 1929, the charter was ratified. The name Dearborn was retained because of its historical significance.

Just a few months later, on October 21, 1929, another major event occurred, the dedication of the Edison Institute. Before such distinguished guests as Thomas Edison, President Herbert Hoover, Madame Curie, Orville Wright, John D. Rockefeller Jr., Will Rogers, and over 500 dignitaries, Henry Ford honored his friend and mentor, Thomas Edison, for his achievements and contributions to mankind. The dedication was made on the exact date of the 50th anniversary of Edison's invention of the first practical incandescent lamp. The climactic moment of the entire dedication was Edison's reenactment of what he had done 50 years before. A narration of the reenactment was broadcast around the world by a voice that many would have recognized at that time, newscaster Graham McNamee.

Another famous event in Dearborn related to Ford concerned the formation of a union at Ford Motor Company. On May 26, 1937, the famous "Battle of the Overpass" occurred on Miller Road. A group of UAW officials attempted to distribute union materials to Ford workers as they walked across an overpass leading from the Rouge Plant. Security officials assaulted the men, using violence and intimidation to warn away any who tried to spread ideas about unionization. The act caused public sympathy to shift toward the organizers, and in 1941, Ford agreed to a UAW contract.

An occasion that Dearborn has been noted for around the country for many years is Memorial Day. Starting in 1924, a major part of the observance has been a parade that honors the sacrifice of veterans, past and present. In recent years, the parade has added numerous military air demonstrations and flyovers. The Dearborn parade is the oldest Memorial Day parade in the state of Michigan and the largest in the United States in terms of participants. Today, it regularly draws nearly 100,000 people every year and has been and still is a time-honored tradition to the citizens of Dearborn. Honoring the men and women who have served this country and in many cases, given the ultimate sacrifice, has always been a very important priority to the residents of Dearborn.

During the 20th century, Dearbornites have served and given their lives in every war America has fought. Their names are memorialized in front of city hall. The contributions of Dearbornites were particularly important during the World War II as Dearborn residents took part in defending their country in numerous ways. Many responded to the call of the armed forces and contributed in some capacity overseas. Others helped on the home front by working in the automotive plants that had been converted into wartime production and made Dearborn a major part of the "Arsenal of Democracy." Some worked in offices that needed various kinds of expertise. Money was raised by the citizens via war bond drives. Paper and scrap metal drives were a common occurrence during the war. The ones who died during the war were not forgotten. Dearbornites erected memorials as a reminder that freedom is never free.

A major dedication and celebration took place October 12–14, 1950. It was called the Cavalcade of Dearborn. Its purpose was to celebrate the rich history of the Dearborn area on the 115th anniversary of the arsenal and at the same time, dedicate the opening of the Dearborn Historical Museum, housed in the former Commandant's Quarters. The event was a combination of pageant and parade and presented the dramatic story of Dearborn's past and growth through the years.

Another notable event occurred in May of 1952, when General Douglas MacArthur visited Dearborn on what was proclaimed by the city General MacArthur Day. The occasion of the visit was the general's retirement after 50 years of service in the United States Army. One of the highlights of his visit was administering the Oath of Loyalty to city employees. In the year of the American Bicentennial, the city staged the American Revolution Bicentennial Jubilee. There were numerous festivities, including a huge pageant and dedication of Arsenal Park at the Commandant's Quarters. Another event that depicted the early history of the area was started in 1987, the Rendezvous on the Rouge. The annual reenactment, the largest of its kind in the country, was an attempt to demonstrate to the residents of Dearborn what the area and life was like during Michigan's French and British colonial period, twenty years before the American Revolution.

Dearborn Homecoming, an event that takes place every August, is a celebration of community as many former residents return home and take part in activities ranging from high school reunions, entertainment, food tents, games, rides, and an awesome fireworks display. Begun in 1980, this event has seen tremendous growth and increasing numbers of visitors. The annual festival, which has drawn more than 125,000 visitors in recent years, provides a chance for residents and former residents to reminisce about Dearborn's past. These are just a few of the events that have meant so much to the citizens of Dearborn, but they illustrate Dearborn's affection for its own heritage and the community's dedication to commemorating a past that should not be easily forgotten.

The Memorial Day Parade has always been an important event in Dearborn. The origins of the parade date back to 1924. Pictured here is an early parade from 1927. (Photograph courtesy Dearborn Historical Museum.)

On Memorial Day 1919, there were celebrations for returning veterans from World War I. This event occurred on Morley and Garrison. In the front row, from left to right, are Mabel Long, Karl Walbarn, John Miller and Jessie Long Helm. The man with the beard in back is Captain George Haigh and second to right in front of him is George Blake. (Photograph courtesy Dearborn Historical Museum.)

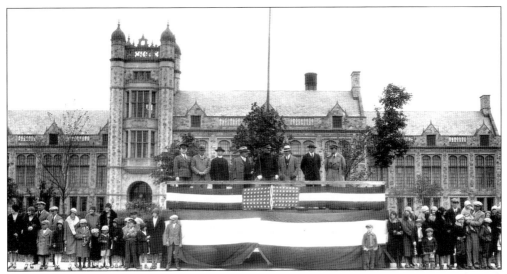

Pictured here is a Memorial Day ceremony in front of Fordson High School on Ford Road. (Photograph courtesy Dearborn Historical Museum.)

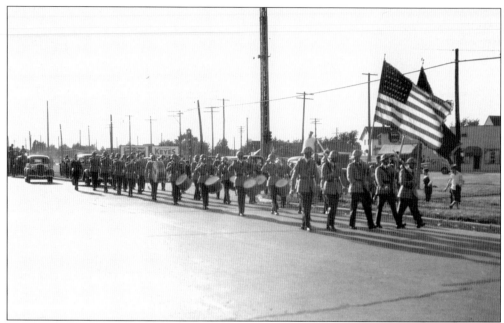

Memorial Day in 1936, this portion of the Memorial Day Parade involves the VFW Drum and Bugle Core 40 & 8. Note the location at Michigan Avenue near Curtis, and Korte's Greenfield Inn in background. (Photograph courtesy Dearborn Historical Museum.)

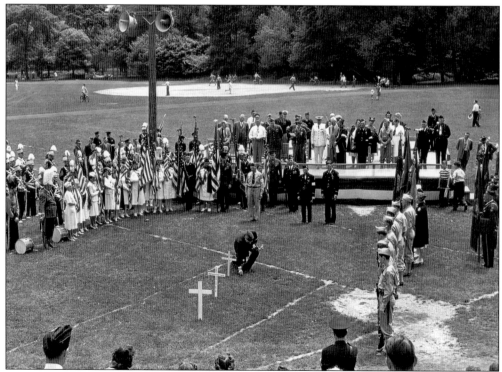

This Memorial Day ceremony was held at Ford Field on May 30, 1946. (Photograph courtesy Dearborn Historical Museum.)

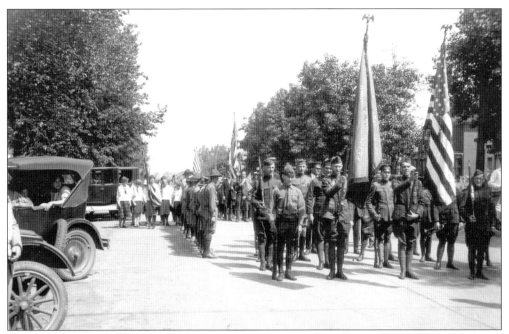

This is a view of soldiers in World War I uniforms parading down what is likely Michigan Avenue on Memorial Day, 1925. The two gentlemen in the lead are carrying the American and the Dearborn Post No. 134 flags. Notice the cars and people in them along the side. (Photograph courtesy Dearborn Historical Museum.)

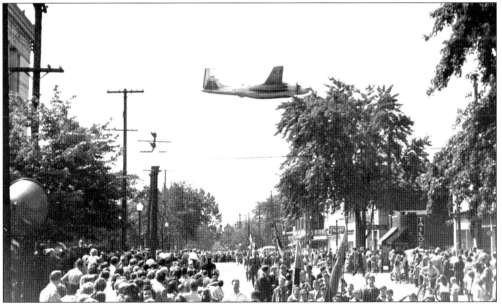

Pictured here is another Memorial Day celebration, this time in 1948 on Monroe Street, north of Michigan Avenue. Note the bomber flying overhead; this is still a popular element of Dearborn parades. The focus of Memorial Day in Dearborn has always been to honor the men and women of America's armed forces who have given their lives while serving our nation. (Photograph courtesy Dearborn Historical Museum.)

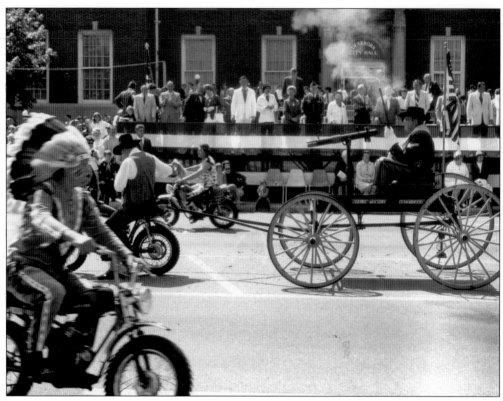

The Memorial Day parade usually has something for the whole family. Bands, clowns, singing, and food are featured, and pictured here, in 1979, a little fun with the cavalry, the "cowboys" and the "Indians." (Photograph courtesy Dearborn Historical Museum.)

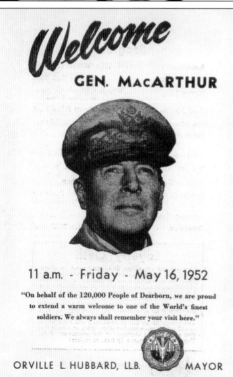

Welcome

GEN. MacARTHUR

11 a.m. - Friday - May 16, 1952

"On behalf of the 120,000 People of Dearborn, we are proud to extend a warm welcome to one of the World's finest soldiers. We always shall remember your visit here."

ORVILLE L HUBBARD, LL.B. MAYOR

On May 16, 1952, Dearborn welcomed General Douglas MacArthur and his wife. The day was named in honor of General MacArthur for his 50 years of service in the United States Army. One of the highlights of the day was the administering of the Loyalty Oath to the city employees with the help of General MacArthur. (Photograph courtesy Dearborn Historical Museum.)

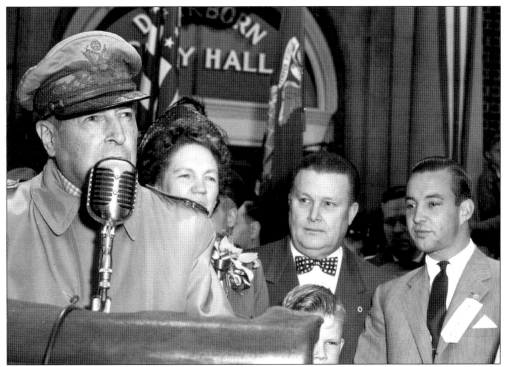

Pictured here, from left to right, are the following: General MacArthur, addressing the crowd, Councilwoman Lucile McCollough, Mayor Hubbard, William Clay Ford, and Mayor Hubbard's son, Henry Ford Hubbard. (Photograph courtesy Dearborn Historical Museum.)

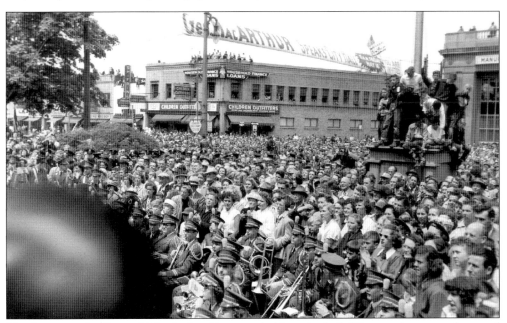

The festivities for General MacArthur Day were held at city hall. Thousands came to hear and honor a man who had given his life to service for his country. (Photograph courtesy Dearborn Historical Museum.)

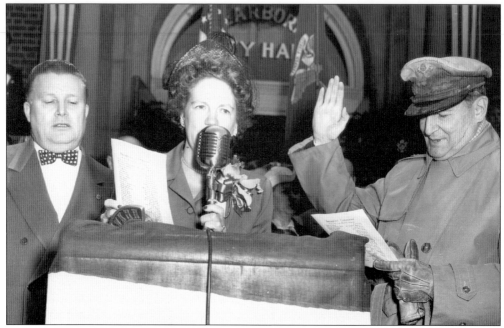

General MacArthur, right, assists Mayor Hubbard and Councilwoman Lucille McCollough in giving the loyalty oath to the City of Dearborn employees. (Photograph courtesy Dearborn Historical Museum.)

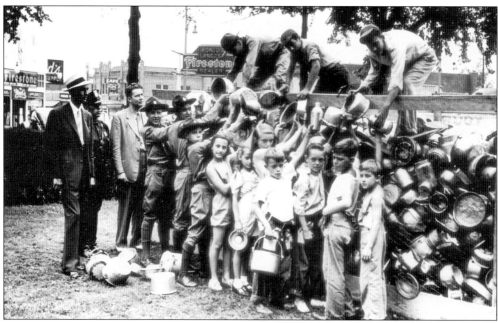

During World War II, everyone contributed to the effort. Pictured here at the city hall complex on July 28, 1941, are boys and girls collecting aluminum for a scrap drive. Behind the children is a sign that reads, "Deposit Your Scrap-Spare Aluminum Here." These collections were common during the war and the scrap collected was recycled to supplement raw materials needed to make weapons and war materials. (Photograph courtesy Dearborn Historical Museum.)

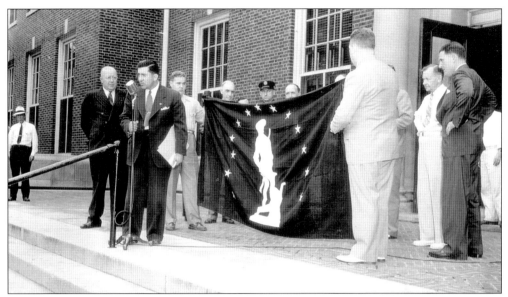

Pictured here is the Bond Flag presentation at Dearborn City Hall. During the war, many drives were held to sell war bonds to financially support the war effort. The sale of war bonds in the United States totaled over $49 million, thus financing the entire war. Pictured are Mayor Orville L. Hubbard (back to camera) William J. Schaefer (to the left at the microphone), and Anthony Esper (next to Mayor Hubbard). (Photograph courtesy Dearborn Historical Museum.)

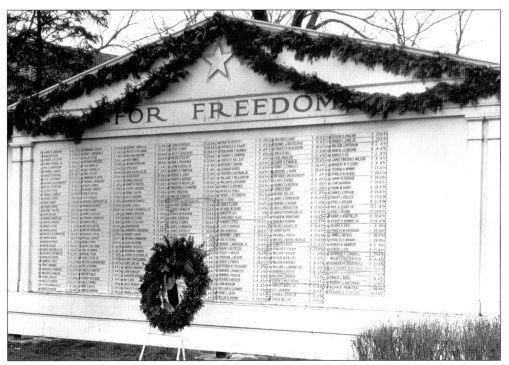

The memorial board in front of city hall in December 1948 honors those who died during World War II. The names of 250 servicemen and women who gave the ultimate sacrifice for freedom are listed. (Photograph courtesy Dearborn Historical Museum.)

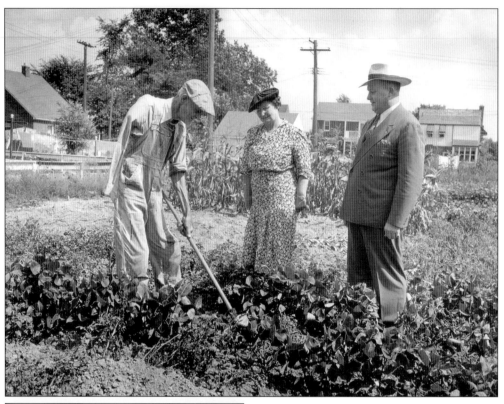

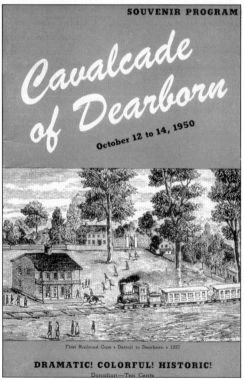

Cavalcade of Dearborn

October 12 to 14, 1950

First Railroad Cars • Detroit to Dearborn • 1837

DRAMATIC! COLORFUL! HISTORIC!

Donation—Ten Cents

Citizens were encouraged to grow their own victory gardens because the commercial farmers were busy feeding the army. Millions of Americans planted gardens in their backyards. In Dearborn, the victory garden chairman urged all residents to raise their own food. Pictured is Mrs. W.J. Yeager, who was made chairman of the Dearborn victory garden program by Mayor Hubbard, as she gives considerable study to the work assigned to her. Pictured from left to right are unidentified man, Mrs. Yeager, and Mayor Hubbard. (Photograph courtesy Dearborn Historical Museum.)

Cover of sample program given out during the Cavalcade of Dearborn in 1950. The festivities highlighted the rich history of the Dearborn area and the dedication of the Commandant's Quarters for use as the Dearborn Historical Museum. (Photograph courtesy Dearborn Historical Museum.)

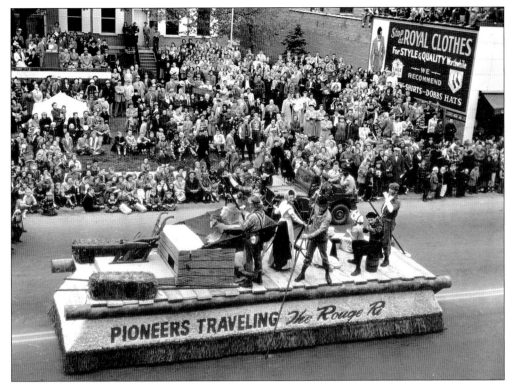

The celebration for the Cavalcade of Dearborn was a combination of pageant and parade. The parade portion featured floats that told the history of Dearborn. This float, in front of the Commandants Quarters on Michigan Avenue, demonstrates the fact that early settlers came up the Rouge River in order to reach the interior of the land. (Photograph courtesy Dearborn Historical Museum.)

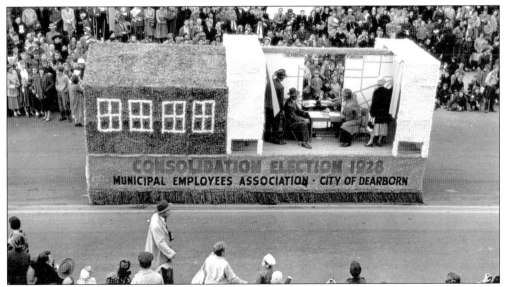

One of the featured floats designed to tell the history of the area highlighted the consolidation of Fordson and Dearborn into one city in 1928. (Photograph courtesy Dearborn Historical Museum.)

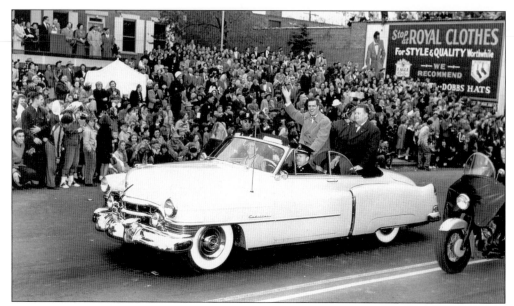

Taking part in the parade at the Cavalcade of Dearborn on October 14, 1950 are the following: (back of car) Mayor Hubbard and Governor G. Mennen Williams; (front seat) Police Chief Ralph B. Guy and Councilwoman Marguerite C. Johnson. (Photograph courtesy Dearborn Historical Museum.)

Pictured here is the scene of the dedication ceremony of the Dearborn Historical Museum. Hundreds attended the celebration and opening of the Commandant's Quarters as part of the Cavalcade of Dearborn. Yet another example that Dearbornites have always loved and celebrated their history. (Photograph courtesy Dearborn Historical Museum.)

Descendants of early settlers were part of the festivities for the Cavalcade of Dearborn. Gathering on the steps of Henry Ford's birthplace in Greenfield Village, from left to right, Louis Howe, Elizabeth Smith, Keith and Mrs. Howard, Carl and Betsy Richard, all in period clothing. (Photograph courtesy Dearborn Historical Museum)

The Rendezvous on the Rouge, initiated in 1987, was a two-day historical event that demonstrated what life was like in the Dearborn area during Michigan's French and British Colonial period. The time period the re-enactors portrayed was 1760, when France and England were engaged in a conflict known today as the French and Indian War. Pictured is the entrance to the event held on Ford Field in 1991. (Photograph courtesy Dearborn Historical Museum.)

Rendezvous on the Rouge re-enactor Michael Dotson, from the group "Coureur de Bois de la Illinois," commands a group of Coureur de Bois "woods runners" as they prepare to advance on British forces. Coureur de Bois were French allies of mixed ancestry; their fathers were likely French fur traders and their mothers, Native American. The Coureur de Bois almost always lived with the Native Americans and were instrumental in the French fur trade. (Photograph courtesy Dearborn Historical Museum.)

A Rendezvous on the Rouge re-enactor demonstrates how women spinned wool into yarn after it was sheared off the sheep. The demonstration of crafts such as this highlights how much is taken for granted in today's computerized and mechanized world. (Photograph courtesy Dearborn Historical Museum.)

Every August, the City of Dearborn celebrates its heritage with a Homecoming festival. Founded in 1979, the three-day event features high school reunions, entertainment, crafts, an art show, games, carnival rides, and fireworks. Attendance at the festival grows every year, attracting people from all over the area. Pictured below is the 1982 Homecoming celebration, which featured vehicles from all eras. (Photograph courtesy Dearborn Historical Museum.)

Top: Class reunion areas are set up every year for former classmates to reminisce. Many former residents come back to Dearborn for the weekend to enjoy the festivities and to talk about memories of their days in Dearborn. (Photograph courtesy Dearborn Historical Museum.)

Middle: The hill at Ford Field is covered with blankets, ready for another exciting and fun-filled Homecoming. (Photograph courtesy Dearborn Historical Museum.)

Bottom: On August 5, 1982, visitors to Homecoming tried to beat the "Circle Lap Sit" record of 1400 people. It was hoped that Dearborn could break California's record, but only 399 participated. (Photograph courtesy Dearborn Historical Museum.)

Nine

DEARBORN TODAY

The history of mankind is a history of change. The same could be said of a town, village, or city. In many ways, the City of Dearborn is one of the best examples of the American spirit, and the mettle and unique character it takes to weather the storms and changes that life brings. The changes of the last 30 years have transformed Dearborn into a modern city with an appreciation for its past.

The organization of the Ford Motor Land Development Corporation in 1970 to develop large tracts of land helped spur development unheard of in cities the same size or even larger. One of the first buildings constructed under this program was the United Airlines building on Michigan Avenue. Many others would follow: AAA of Michigan Headquarters, Parklane Towers, the Hyatt Regency Hotel, and the Henry Ford Hospital Fairlane Center. The major mall in the city, Fairlane Town Center, is one of the largest in the country with over 200 stores.

Although known around the world as the world headquarters of Ford Motor Company, the city is also home to more than 200 small businesses. In addition to Ford Motor Company, the major employers are Oakwood Health Services, AAA of Michigan (headquartered in Dearborn), United Technologies, Pioneer Engineering, and Livernois Engineering. Dearborn is also a location of growing retail and office development. All along its main thoroughfares—Telegraph Road, Michigan Avenue, and Ford Road—are commercial and office structures, hotels, shopping plazas, restaurants, and cultural facilities.

Dearborn schools strive for academic excellence, providing educational opportunities ranging from preschool to graduate school. Dearborn is one of only three K–14 school systems in Michigan, with a two-year college program available as part of the program at Henry Ford Community College. There are presently over 13,000 students enrolled in Dearborn schools, which offers a broad curriculum and stresses basic skills development. The University of Michigan–Dearborn provides students with excellent educational opportunities that are closely linked with the business, government, and industry of the region. Another opportunity to attend a university in the city is afforded at Davenport University (formerly, Detroit College of Business), which has an excellent academic reputation around southeast Michigan. The educational opportunities in Dearborn are virtually endless.

One of the most visited history attractions in the United States, the Henry Ford Museum and Greenfield Village, attracts over one million visitors annually. An IMAX theater was recently added to the complex, with the Automotive Hall of Fame not far away. The city still retains its reputation for clean surroundings, outstanding public services, and excellent schools. In the

area of recreation programs, Dearborn has nearly 150 separate facilities including parks, golf courses, swimming pools, and ice arenas.

The Rouge River has become polluted over the years and residents have initiated a clean-up campaign. Industry, government, and the city have combined to bring the river back to its former glory. The group is called the Rouge River Gateway Partnership. It has achieved much success so far, but the big picture eventually will include walkways and bikeways, boat tours up and down the river with stops at the Henry Ford Museum and Greenfield Village and the Henry Ford Estate. Fish that have not been seen for years have come back to the river. The goal is to turn the Rouge River into a vibrant source of recreation and nature. An Environmental Interpretive Center has just been completed on the grounds of the University of Michigan–Dearborn that will help to tell the story of the river. The center will be the focal point of environmental efforts to continue clearing up the river and preserving the natural habitat.

The most recent addition to the City of Dearborn is the crown jewel of the area: The Ford Community and Performing Arts Center offers residents a first-rate facility in which to enjoy a number of activities. Built on the site of the former Civic Center (part of the old was incorporated into the new), the center has a 1,201 seat auditorium that boasts a professional entertainment season including theatrical, vocal, and musical performances. A section of the center is an art gallery that showcases a new exhibit every six weeks. The fitness area boasts two pools, two full-court gymnasiums, a dance/aerobic area, weight/cardiovascular area, a running/walking track, and a rock climbing wall. There is also a wing for senior citizen activities. National artists use the theater and art gallery, but local and regional artists also have use of this beautiful facility, and it serves as home to many local art organizations and performance groups.

What an incredible journey Dearborn has been through: from the time of the early ribbon farms and settlers to the U.S. Arsenal; from the coming of the railroad and industrialization; from farmland to modern city. Through it all, there is one common thread: people. People with vision and a willingness to work hard to see dreams through to fruition characterize those who have settled in the City of Dearborn. Residents of Dearborn have always loved their history, but have also had a vision for the future. For Dearbornites, life is about living in a great community with good schools, great recreational facilities, and making life better every day. To live in Dearborn is to live in a community with a rich history, clean surroundings, and a reputation for city services. At the same time, it is a city that has grown into a business and industrial center. If the early settlers were here today, they would not recognize the area they first moved into 200 years ago. However, one thing is certain: the citizens of today can say what William Nowlin said of those early pioneer days: it's "getting to be quite a country." The name of that country is Dearborn.

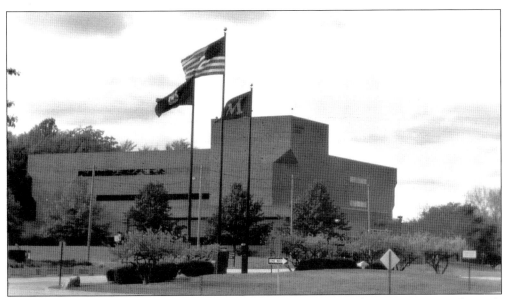

Dearborn has always had a reputation for great schools and that tradition continues today with the University of Michigan–Dearborn on Evergreen Road. Founded in 1959 with a gift of 196 acres from the Ford Motor Company, it has grown into a comprehensive university offering undergraduate and master's degrees in arts and sciences, education, engineering, and computer science. More than 70 acres of the campus is maintained as one of the largest natural areas in metropolitan Detroit. The Henry Ford Estate is located on the campus and is open to touring. (Photograph courtesy Kimberly Rising.)

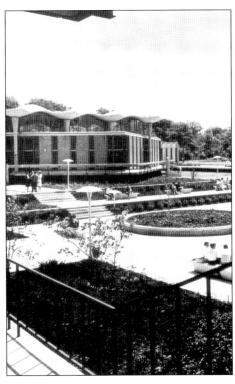

Henry Ford Community College, founded in 1938, was originally located in the basement of Fordson High School to provide Fordson students with more advanced classes. It was first called Fordson Junior College, then Dearborn Junior College, and renamed after Henry Ford in 1952 after the Henry Ford Trade school donated money and equipment to the college. Today, the school offers a wide range of classes and fields of study and has a great reputation for educational excellence in Dearborn and throughout southeastern Michigan. (Photograph courtesy Dearborn Historical Museum.)

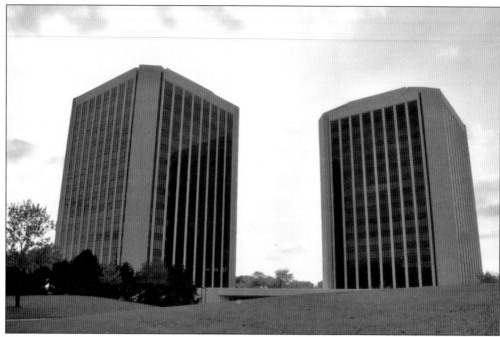

The Parklane Towers were part of a building program that started when Ford Motor Land Development Corporation was organized in 1970. The twin commercial buildings were completed in 1971 and 1973. Known by area residents as the "twin towers" or the "salt and pepper shakers," the office structures offer many amenities to the employees who work in the towers. (Photograph courtesy Kimberly Rising.)

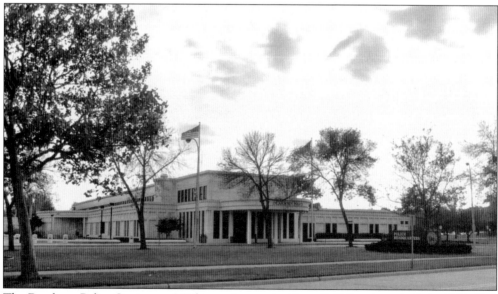

The Dearborn Police Station on Michigan Avenue by Greenfield Road was built in 1961. The building was recently renovated and the additions transformed the entire complex into a source of pride for Dearborn residents. (Photograph courtesy Kimberly Rising.)

The Ford Woods Ice Arena on Ford and Greenfield Roads was renamed the Mike Adray Sports Arena in 1981 in honor of Michael Adray's (owner of Adray Appliance) tremendous support of Dearborn athletics. It underwent a major renovation and expansion that made the complex a world-class facility featuring two ice skating surfaces, a banquet room, a pro shop, a 4,000-square-foot lobby and more. (Photograph courtesy Kimberly Rising.)

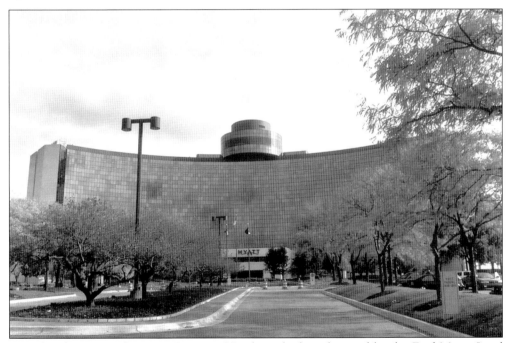

Completed in 1976, the Hyatt Regency Hotel was built and owned by the Ford Motor Land Development Corporation. In January of 2000, the building was renovated and now features a 16-story atrium lobby, 772 guest rooms, 3 ballrooms, 3 restaurants, a fitness center, and a revolving rooftop lounge. (Photograph courtesy Kimberly Rising.)

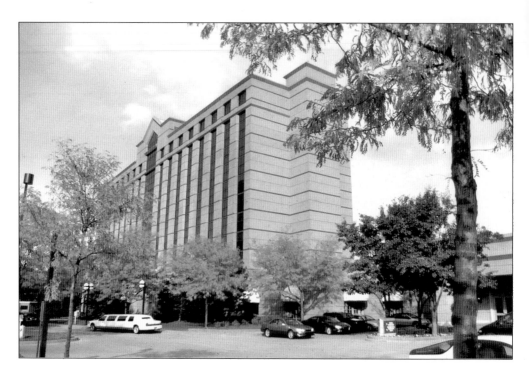

As one of the newest hotels in Dearborn, the Ritz-Carlton (above) is an integral part of a 17-acre, mixed-use project called Fairlane Plaza. The hotel has 308 guest rooms and offers first-rate services and amenities. The rest of Fairlane Plaza includes two huge structures that offer office and rental space (below). (Photograph courtesy Kimberly Rising.)

The original Automobile Club of Michigan building was erected in 1974 at Hubbard Drive and Southfield Road. It recently went through a major renovation and continues to operate as the headquarters of AAA of Michigan. (Photograph courtesy Kimberly Rising.)

Dearborn's Ford Community and Performing Arts Center opened in 2001 and offers citizens a first-rate, multi-purpose facility. It is North America's largest municipally-owned community recreation and cultural complex. The facility offers numerous recreational opportunities including two pools, basketball and volleyball courts, a dance studio, a weight area, a walking/running track, and a rock climbing wall. The complex also has a senior citizen wing with a lounge and activity rooms. The 1,201-seat theater features the latest in lighting and sound systems and is used by professional artists as well as local cultural arts programs. (Photograph courtesy Kimberly Rising.)

SELECTED

BIBLIOGRAPHY

Bryan, Ford R. *Henry's Attic*. Edited by Sarah Evans. Dearborn: Ford R. Bryan 1995.

Bryan, Ford R. *Beyond the Model T: The Other Ventures of Henry Ford*. Edited by Philip P. Mason. Detroit: Wayne State University Press 1997.

Bryan, Ford R. *The Fords of Dearborn: An Illustrated History*. Third Printing. Detroit: Harlo Press 1992.

Catton, Bruce. *Michigan: A History*. Edited by James Mortan Smith. New York: W.W. Norton & Company, Inc. 1984.

Dearborn: Fifty Years of Progress. Dearborn: Dearborn Historical Museum 1979.

Head, Jeanine M. and William S. Pretzer. *Henry Ford: A Pictorial Biography*. Edited by Margo MacInnes. Dearborn: Henry Ford Museum and Greenfield Village 1990.

Lewis, David L. *The Public Image of Henry Ford: An American Folk Hero and His Company*. Detroit: Wayne State University Press 1987.

Nowlin, William. *The Bark Covered House*. Sixth Printing. Edited by Milo Milton Quaife. Dearborn: Dearborn Historical Commission 1992.

O'Callaghan, Timothy J. *Henry Ford's Airport and Other Aviation Interests 1909-1954*. Ann Arbor: Proctor Publications 1995.

Werling, Donn P. *Henry Ford: A Hearthside Perspective*. Warrendale: Society of Automotive Engineers, Inc. 2000.

The Encyclopedia of Michigan: 1999. Volume 1. St. Clair Shores: Sumerset Publishers 1999.

ARTICLES

Arneson, Winfield H. *The Builders of Dearborn: Clyde M. Ford*. The Dearborn Historian, Volume 33, no. 4 (Autumn 1993) 113-114.

———. "The Builders of Dearborn: The Ten Eyck Taverns Conrad Ten Eyck & Frank A. Gulley." *The Dearborn Historian*, Volume 31, no. 4 (Autumn 1991) 107-109.

———. "The Builders of Dearborn: Bark Covered House Fame, William Nowlin; Village of Springwells First President, Charles T. Horger." *The Dearborn Historian*, Volume 40, no.3 (Summer 2000) 85-87.

———. "The Builders of Dearborn: Long-Time Dearborn Educator: Ray H. Adams; Six Mile House Proprietor: John H. Schaefer; Pioneer Brickmaker – Public Servant: Titus Dort." *The Dearborn Historian*, Volume 29, no. 1 (Winter 1989) 21-25.

————. "The Builders of Dearborn (Ninth in a series): Michael McFadden and James M. Guinan." *The Dearborn Historian*, Volume 32, no. 1 (Winter 1992) 16-19.

————. "The Builders of Dearborn: William B. Stout: Engineering Wizard (Fifteenth in a Series)." *The Dearborn Historian*, Volume 37, no. 2 (Spring 1997) 53-54.

————. "Howe-Peterson Funeral Home Celebrates 125 Years In Dearborn." *The Dearborn Historian*, Volume 38, no. 3 (Summer 1998) 67-74.

————. "The Builders of Dearborn (Tenth in a Series) Charles Roulo and Herman Kalmbach." *The Dearborn Historian*, Volume 32, no. 2 (Spring 1992) 47-49.

————. "The Builders of Dearborn (Seventh in a Series) Louis W. Howe, Joseph M. Karmann, Graham Brothers." *The Dearborn Historian*, Volume 31, no. 2 (Spring 1991) 50-55.

————. "The Builders of Dearborn (Fifth of a Series) William Daly, Colonel Joshua Howard, Dr. Edward S. Snow." *The Dearborn Historian*, Volume 30, no. 2 (Spring 1990) 48.

————. "The Builders of Dearborn: Lee Hankinson and Samuel D. Lapham (Fourteenth in a Series)." *The Dearborn Historian*, Volume 36, no. 2 (Spring 1996) 54-56.

Gorenc, Louis. "Man's Bending of the Rouge River's Will." *The Dearborn Historian*, Volume 39, no. 1 (Winter 1999). 3-11.

Gould-McElhoue, William K. "Camp Dearborn: Citizen's Country Club." *The Dearborn Historian*, Volume 37, no. 3 (Summer 1997) 67-73.

Luedtke, Eleanor. "A Quiet Retreat." *The Dearborn Historian*, Volume 37, no. 2 (Spring 1997) 42-52.

Mamalakis, Helen K. "Battle of the Overpass: Sixty Years Ago." *The Dearborn Historian*, Volume 37, no. 2 (Spring 1997) 35-41.

Woolworth, Nancy L. "The Potawatomi of the Rouge." *The Dearborn Historian*, Volume 6, no. 3 (Summer 1996) 31-45.

INTERNET

The First Methodist Church of Dearborn, Michigan.
www.geocities.com/hist.mich/dbnchurch.html.

Dearborn Heights, Wayne County, Michigan. From "American Local History Network: Michigan."
www.geocities.com/michhist/dbnhts.html

Dearborn Public Schools. From "Dearborn Public School-District".
www.dearbornschools.org/District/district.html

Dearborn. From "Michigan Historical Markers."
www.dearbornchamber.org/history.htm

Tourist Attractions. From "Visiting Dearborn."
www.dearbornchamber.org/visiting-dearborn/recreation.htm

Education. From "Moving to Dearborn".
www.dearbornchamber.org/moving-to-dearborn/education.htm

Dearborn's Ford Community & Performing Arts Center.
www.dearbornfordcenter.com/theater.

Hatch, Jean H. *A Capsule History of Dearborn.* Published and adapted with permission from the Dearborn Historical Commission.
www.dearborn-mi.com/history.htm

Ford Homes Historic District. From "Dearborn, Michigan, Tour-Dearborn Historic Homes District."
www.steve-hatfield.com/dfeature.htm

Dearborn: Located in Wayne County. From "Welcome to Dearborn, Michigan!
HomeTownValue.com."
www.hometownvalue.com/dearborn.htm

Michigan in Brief: Information About the State of Michigan. From "Michigan in Brief-Library of
Michigan."
www.libofmich.lib.us/publications/miinbrief.html

Michigan Through the Years: A Brief History of the Great Lake State. From "Michigan Through the Years,
A Brief History, Michigan Historical Center."
www.sos.state.mi.us/history/michinfo/briefhis.htm

Dearborn: Wayne County, Michigan From "Century 21 Curran & Christie-Community Information."
www.century21cc.com/general/comminfo.htm

Dearborn's First Schoolhouse.
www.geocities.com/histmich/schoolhouse.html

Dearborn Township Board Meetings and Members. From "Dbn Township Board Meeting's and
Members"
www.geocities.com/histmich/dbnmeet.html

Ford, Henry A. *Wayne County, MI – Pioneer Records: Detroit in 1838.* From "Pioneer & Historical
Collections, Volume X, pgs 97-104."
www.usgennet.org/usa/mi/county/wayne/detroit1838.htm

The History of Gulley Farm: Dearborn, Michigan. From" American Local History Network: Michigan."
www.geocities.com/michhist/gulleyfarm.html

The History of the Henry Ford Estate.
www.umd.umich.edu/fairlane/history.html

The Dearborn Arsenal-Dearborn, Michigan, Wayne County.
www.geocities.com/histmich/dbnarsenal.html